# Remembering
# Plant City

# Remembering Plant City

## Tales from the Winter Strawberry Capital of the World

### Gilbert Gott

Charleston · London
History Press

Published by The History Press
Charleston, SC 29403
www.historypress.net

Copyright © 2007 by Gilbert V. Gott
All rights reserved

*Cover image:* Souvenir Program cover from the Florida Strawberry Festival, February 23–28, 1953, sponsored by the Norman McLeod American Legion Post No. 26, depicting the Plant City area's delicious strawberries.

First published 2007

Manufactured in the United Kingdom

ISBN 978.1.59629.243.7

Library of Congress Cataloging-in-Publication Data

Gott, Gilbert.
  Remembering Plant City : stories from the winter strawberry capital of the world / Gilbert Gott.
     p. cm.
  ISBN 978-1-59629-243-7 (alk. paper)
  1. Plant City (Fla.)--History--Anecdotes. 2. Plant City (Fla.)--Social life and customs--Anecdotes. 3. Plant City (Fla.)--Biography--Anecdotes. 4. Historic buildings--Florida--Plant City. 5. Plant City (Fla.)--Buildings, structures, etc. I. Title.
  F319.P59G68 2007
  975.9'65--dc22
                                    2006103066

*Notice*: The information in this book is true and complete to the best of our knowledge. It is offered without guarantee on the part of the author or The History Press. The author and The History Press disclaim all liability in connection with the use of this book.

All rights reserved. No part of this book may be reproduced or transmitted in any form whatsoever without prior written permission from the publisher except in the case of brief quotations embodied in critical articles and reviews.

# Contents

| | |
|---|---|
| Foreword by David E. Bailey Jr. | 7 |
| Preface | 9 |
| Acknowledgements | 11 |
| Introduction | 13 |
| | |
| An Overview of Plant City's Unique History | 15 |
| The Florida Strawberry Festival | 25 |
| The Grand Parade: A Plant City Spring Tradition | 29 |
| The Baby Parade | 32 |
| The World's Largest Strawberry Shortcake: Plant City, Florida, February 19, 1999 | 35 |
| The Plant City Christmas Parade: A Tradition and a Treasure | 41 |
| African Americans in Plant City | 45 |
| The Plant City Chamber of Commerce at Eighty Years | 50 |
| Pioneering Families: Hawkins Corner | 54 |
| Joe McIntosh: Cucumber King and More | 61 |
| Everyone Flocked to the Cane Grinding | 64 |
| The Macks of Plant City | 67 |
| Mr. E.L. Bing: Educator and Leader | 72 |
| Lew James Prosser: Plant City Agriculturist and Businessman | 79 |
| R.E. "Roy" Parke and Parkesdale Farms | 82 |

## Contents

| | |
|---|---|
| The Southland Frozen Foods Corporation and D. Herman Kennedy | 85 |
| Nothing Like Hometown Banking | 91 |
| The Young and Moody Building: A Multifaceted Showpiece | 99 |
| The Wright Arcade: A Unique Story | 103 |
| Tickel's Bicycle Shop: A Plant City Favorite | 106 |
| The Kilgore Seed Company | 109 |
| The Wells Funeral Homes | 112 |
| New Hotel Plant Reflects Civic Pride | 116 |
| The Coca-Cola/Pollock Building | 120 |
| Badcock Furniture Celebrates "A Century of Success" | 123 |
| C.R. "Jack" Hooker and Hooker's Department Store | 126 |
| The Rayburn Potato Business in Plant City | 129 |
| Everyone Remembers Donna | 133 |
| Fire: A Community's Nemesis | 137 |
| Plant City and Baseball: A Long and Loving Relationship | 140 |
| Plant City's Movie Houses Were a Delight for All | 144 |
| Plant City's Own Radio Station | 148 |
| Plant City's Schools Over the Years | 153 |
| The Boys and Girls—Men and Women—of Plant City's Greatest Generation | 159 |
| Central Park: The Heart of the City | 162 |
| The Bruton Memorial Library | 165 |
| The Heritage Award: Two Profiles | 170 |
| Moving Experiences: The Relocation of Three Plant City Homes | 179 |
| Plant City Union Station: "The Depot" | 186 |

# Foreword

It has been said that one picture is worth a thousand words. If this is true, the photographs in this publication, *Remembering Plant City: Tales from the Winter Strawberry Capital of the World*, are worth a fortune! And the narration accompanying them adds to their historical significance. The visual portrayal of people and places in "Strawberry Town" (Plant City) and east Hillsborough County will bring back many memories of those persons and events that have shaped our history and heritage. When the photograph is combined with oral tradition and folklore, the past truly comes to life, giving us vivid preservation of the past.

This book is the brainchild of local developer Ed M. Verner and Gilbert V. Gott, adjunct instructor of history at Hillsborough Community College. These historical stories and photographs are from the collection of Plant City Photo Archives, Inc., and have been published monthly in *FOCUS* magazine through the efforts of Gil Gott and his interviews with many local residents as a part of the Oral History Project of Plant City Photo Archives. Some of these articles have also appeared in *In The Field* magazine and the local weekly newspaper, the *Courier*.

A special thanks is due Betty Patton, image processing coordinator, for digitizing, computerizing and restoring these old photographs, using a special system of image preservation and retrieval.

# Foreword

Many volunteers have given service to these efforts. We are especially grateful for the work of Betty Watkins, Bill Parolini and Steve Smith, who have been so very helpful.

Thanks also to those persons who so willingly supplied photos and information about our community. The gracious heritage we have in our lives comes from the distant past through the spirit and fortitude of our farsighted pioneer predecessors, who so courageously ventured into the strange wilderness that is now called east Hillsborough County.

Through their sacrifices and struggles we have inherited much for which we can be thankful—may we continue to build well on the firm foundation that has been laid for us.

So sit back, relax, remember Plant City and enjoy these delightful photographs and stories.

David E. Bailey Jr.
Co-author with Quintilla Geer Bruton of *Plant City: Its Origin and History*

# Preface

Believing in the magic of photographs, Plant City Photo Archives set out to preserve the history and heritage of the greater Plant City community by collecting and preserving its historic photographs. We began to collect, as well as possible, the stories around the photographs. We have collected, scanned, digitized and preserved over forty thousand photos and have been gathering information about these photos along the way.

Photos do tell a story in themselves. We printed eight-by-ten prints and many enlargements—one as large as eleven feet by four feet—and set up exhibits at the library, local banks, the Greater Plant City Chamber of Commerce and a number of other locations. Although exhibit attendees were enchanted by the photos, they had continuing questions about the people, places and activities shown in them. We realized that to tell the full story about the photographs, we needed to provide the words that describe those people, places and things.

We began writing the stories that wrapped around and put life in the photos, and began a monthly article in *FOCUS* magazine in Plant City. We also submitted stories and photos to *In The Field* magazine and the local weekly newspaper, the *Courier*. The reader response was overwhelming. After some stories were published, magazines would quickly disappear from the distribution racks. At one point, a woman entered the *FOCUS*

# Preface

magazine office, picked up four copies and left. Curious, the editor went outside and found four women sitting in a car reading the Plant City Photo Archives' article.

We believe the stories about real people, places and things, and especially their accompanying photos, are of interest not only to the Plant City community, but also to anyone who has those special memories of their small town or neighborhood.

Much of the information in the stories is from the Plant City Photo Archives' Oral History Project and its accuracy is not guaranteed. People see the same event differently, and their memories are sometimes a little less than perfect.

We have also relied heavily on the information presented in the Quintilla Geer Bruton and David E. Bailey Jr. book, *Plant City: Its Origin and History*, first published in 1977 and updated in 1984. The biographical section of that book contains historical information submitted by the families and has not been subject to verification, but there are some great stories there. Local newspapers have also been a source of information, including the *Tampa Tribune* and the *Courier*, and we have found that on occasion they have been less than factual. There is also a smattering of other sources, most of which we categorize as part of our Oral History Project.

Hence, although we attempt to write what actually happened, when, where, why, how and by and with whom, history can be slippery, and we cannot guarantee all the details. Nonetheless, we believe these to be good stories about good people and a good community. We hope you enjoy them.

# Acknowledgements

Neither Plant City Photo Archives nor this book would exist without the help and support of a number of wonderful individuals. It was Ed Verner's wisdom and vision that brought about the founding of the Plant City Photo Archives, and it is Dr. John Verner, Mrs. Sally Verner and the Verner Foundation that have continued to breathe life into the organization.

Special gratitude is due Betty Patton for her untiring labor and fastidiousness in scanning and enhancing the more than forty thousand historic photographs in our collection, and David Patton has kept our computers, scanners, printers, etc., operating smoothly.

Members of the Plant City Photo Archives' Advisory Council have been especially helpful and instrumental in our success. These include Robert and Ann Trinkle, Dr. Hal Brewer, Bob Edwards, Mac Smith, Judy Martin and Marion Smith.

David E. Bailey Jr. has been our historian in residence; Bill Parolini and Lou Baird have been irreplaceable with regard to our exhibits; and Al Berry has provided much A/V and marketing support. Stanley and Susan Kolker and Linda Smith have worked assiduously in presenting our soirees, "An Evening of Picture Perfect Memories"; Steve Smith has produced outstanding videos and assisted in marketing; and Vicki Hawthorne,

# Acknowledgements

Eleanore McDade, Bill Thomas and Betty Barker Watkins have been invaluable in producing our photographic displays.

Editorial assistance has graciously been provided by Anne Haywood and Robin Emery, and we gratefully acknowledge the following for their continuing support: Danny Coton, Martha Dixon, Ken Gibbs, Rich and Judy Glorioso, Tim Martin, John McCaughey, Dub McGinnes, Mac McGrath and Maribeth Mobley. And we gratefully recognize our many other supporters, including the late Billy Pou and Mrs. Maida Pou, Raiford (Shorty) Brown and the late Jim Redman and Mrs. Ruby Jean Redman.

We also thank Mike Floyd, publisher of *FOCUS* magazine, and Karen Berry, publisher of *In The Field* magazine, in whose publications much of these stories have earlier appeared.

The photographs appearing here are predominately from the Plant City Photo Archives collections, including the Bill Friend Collection, the Bud Lee Collection and many separate photos donated by individuals and families. A select few were provided by the State of Florida's Florida Memory Project.

The stories were contributed by Betty Patton, Bill Thomas and Gil Gott, who wrote most of them and edited all of them.

Last, I am eternally thankful for the outstanding editorial assistance provided by Jenny Kaemmerlen and Hilary McCullough of The History Press.

And, of course, while I credit all the individuals above for all their assistance, the ultimate responsibility for the facts, errors and omissions remains mine. And I apologize to all those who I inadvertently omitted from this list.

# Introduction

As part of my graduate studies in history I set out to write a brief overview of the small town of Indiana, Pennsylvania, during the years of World War II. Researching the events of this small town of about ten thousand became enthralling. I developed a deep appreciation of the life and spirit of a community that is unveiled through the many stories that are printed and told by the local people.

A survey or overview of the history of a community is informative. The stories, however, are illustrative, and along with their accompanying photographs become magical, transforming objective data into revealing glimpses of the heart and soul of a community.

Plant City Photo Archives began as an attempt to rescue one local photographer's collection from its inevitable dust heap. In a compacted form, photographs can do incredibly more than artifacts and, when coupled with the stories that wrap around those photos—stories that create a fuller picture of the subject than the mere subject itself—the combination becomes a magical transformation.

The stories that follow are written as stand-alone stories and, hence, there may be some redundancy, and there is no necessary sequence. Read them in any order that appeals to you.

Beginning with a brief history, these are some of the stories about the small town of Plant City, Florida, its people, places and events.

# An Overview of Plant City's Unique History

They came from Alabama and Georgia. First came the Seminole Indians. Forced off their lands by the American military, they pushed through Spanish Florida into central Florida, then some were deported and sent to a federal reserve in the West and some escaped into the Everglades, where they continue to reside.

Next came the white settlers, mostly by foot, sometimes with their black slaves, sometimes with miscellaneous livestock and even sometimes with small herds of cattle.

The Indians called it Hichipucksassa, and to Hichipucksassa they came: Reverend Daniel Simmons from Savannah, Georgia; Stephen Hollingsworth from North Carolina; Simeon L. Sparkman from Georgia; John G. Thomas from Georgia; and John and Rabon Raulerson, John Futch, Enoch Collins, George Hamilton, Joseph Howell, the Reverend Samuel Knight and his sons, Joel and Jesse, and a continuing stream of others. Some with plows and farm implements, and some with livestock, all seeking land, whether through federal land grant programs, purchase or squatting. They came to a new life.

The history of Plant City has been written by these many individuals and families who put personal comfort aside and set out to establish a new life in a new world, which became Plant City. Yes, they were strong and courageous. It was a Darwinist world, and only the strong, in might or mind,

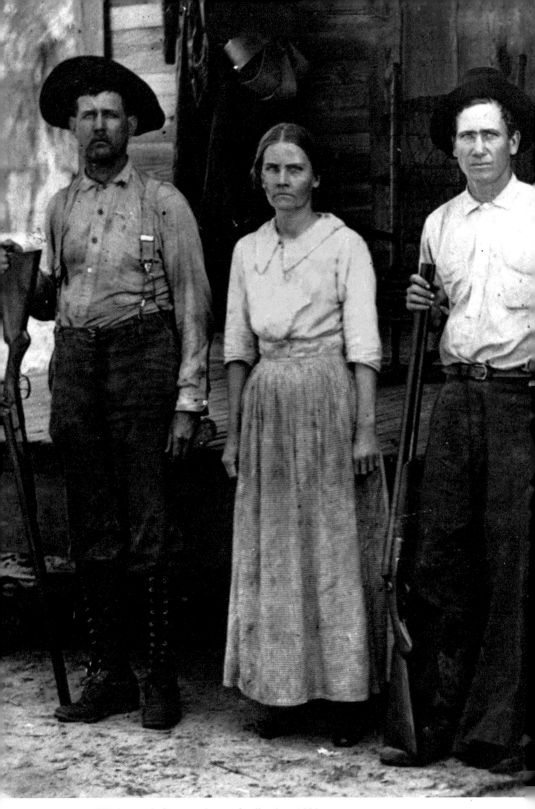
An east Hillsborough County pioneer family, circa 1880s.

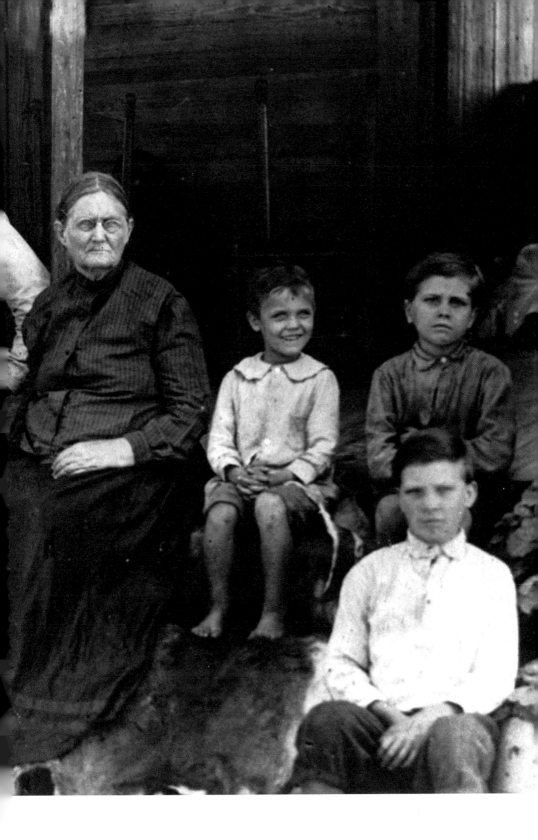

would survive. The tests and challenges were unremitting. Joseph Howell, a member of the Florida House of Representatives, died January 9, 1862, after riding six days from Tallahassee to his home in Springhead in bitter winter weather. John Carey was massacred at his farm April 17, 1856, in an Indian uprising. And Enoch Collins's first wife, Fatima Knight Collins, passed away after bearing fifteen of Enoch's twenty-nine children.

Persevere they did. They were a hardy lot. Hichipucksassa became Cork (named after Cork County, Ireland), and the population grew. By 1860 Hillsborough County had grown to about three thousand residents, with farms dotting the lush green countryside.

The effects of the Civil War were slight at first, then grew deeper, wider, more encompassing. Whole communities began to show signs of strain and disintegration. Returning soldiers were met with yet another challenge. For the freed slaves, the problems of survival were compounded. But they had hope.

Relative economic and social normalcy was restored by the late 1870s; population growth in east Hillsborough continued at a pace faster than the city of Tampa. Within fifteen years of the Civil War several villages developed into substantial communities. And Bealsville, established in the late 1860s by freed slaves, was beginning to prosper. They founded Antioch Baptist Church in 1868, and the black community of Bealsville built a one-room schoolhouse, Antioch School, in 1873.

Cattle and citrus were early money producers for area settlers. There were also tobacco, cotton, fruits and vegetables.

Then came the South Florida Railroad, Henry Bradley Plant's iron horse rolling on polished steel rails. In December 1883 rail service began, connecting Plant City to Tampa, and by January 1884 Plant City connected to Tampa on the west and Sanford to the east.

Prominent citizens—including Mrs. S.E. Mays, James T. Evers, Martha Collins Knight and Mr. W.S. Knight—boarded that special carrier to celebrate this historic development. Captain Francis W. Merrin moved his printing operation to Plant City, established the *South Florida Courier* in 1884 and promptly began promoting the new town.

The referendum to establish a new town was held January 10, 1885, and the votes were forty-nine in favor, one opposed—Plant City was born. Both the town and the railroad grew exponentially. For a short time, Plant City was known as a cotton-shipping center, carrying the produce of Charlie Taylor and many other cotton planters.

But it was timber and not cotton that brought Plant City its first major industry: the Warnell Lumber and Veneering Company, the largest concern of its kind in the South. Because of Warnell, for a decade and a half the town was known as a little mill town. By 1886 the new town had

# An Overview of Plant City's Unique History

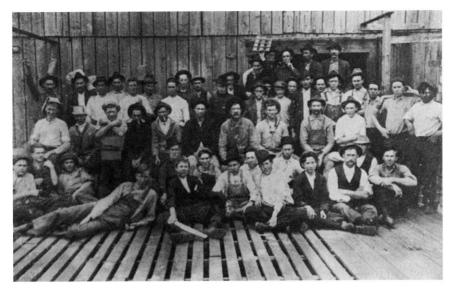

Employees at the sawmill of Warnell Lumber and Veneering Company, circa 1910–20.

a post office, express and telegraph office, thirteen stores, four hotels, three steam sawmills, a gristmill, a weekly newspaper and a carriage maker. The principal shipments were lumber, cotton, cattle, fruits and vegetables.

In his *Early History of the Produce Industry in Plant City*, Lew Prosser, a Plant City businessman, states that, were it not for the Plant railroad system, the history of Plant City would have been vastly different, because in those early days it was the railroad, not the highways, that provided transportation, which is the key to development.

The city continued to grow, despite the yellow fever epidemic of 1887, and in that same year made an all-out effort to construct wood-plank sidewalks. A bond issue in 1902 provided revenue for the city's first brick streets, its water plant and the sewage system.

After the disastrous fires of 1907, which consumed many of the wood structures over several blocks of downtown Plant City, including the building where council meetings were held and records had been kept, the stalwart citizens resurrected a new, brick-built, downtown business district. Business boomed. By 1911, due in large part to the multiple rail connections (rails ran in five directions from the central city) and fifty to sixty trains daily, Plant City was called "the Largest Inland Shipping Point in the State of Florida."

It was a prosperous time in Plant City in the years around 1914. Lumber, citrus, banking, construction, agriculture, phosphate mining, fertilizer, sugar cane and strawberries were all highly profitable businesses. The Roux Composite Brick Company manufactured and sold over five million bricks in 1913.

# *Remembering* **Plant City**

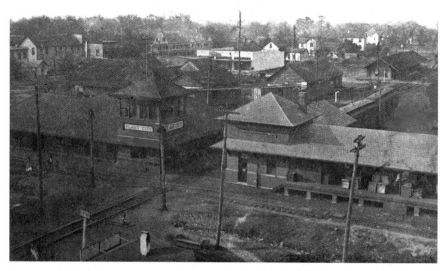

The main rail crossing of north-south and east-west tracks, shipping platforms and passenger station in Plant City, Florida, circa 1920–22.

It was also the year when Plant City residents decided to construct a new high school. The old brick Plant City Graded and High School, built in 1893 and added to in 1904, was again overcrowded. The citizens decided to build a new and magnificent school. The School Improvement Association successfully promoted a $40,000 school bond issue, and the taxpayers agreed to a $5 million levy to finance the project. The beautiful 43,000-square-foot 1914 Plant City High School became a tribute to a community that focused on its future. In 1920 the Midway Academy was built in the southeast sector of the city to serve the black community.

The city was taking on a new appearance. The impressive red-brick city hall at the corner of Mahoney and Collins housed the city offices and departments, as well as the police and fire departments, and even had a courtroom on the second floor. City hall was flanked by the stout First Baptist Church building to the north, and the Masonic Lodge to the west—the central park, site for concerts and city celebrations, was across Mahoney Street to the south. Down the street the Hillsboro State Bank constructed a large new yellow-brick building at Collins and Reynolds, and large two- and three-story architecturally elaborate residences sprang up on the periphery of the booming downtown.

By 1920, Plant City had earned the title "World's Winter Strawberry Capital." Trucks loaded with the luscious red berries would be lined up for

## An Overview of Plant City's Unique History

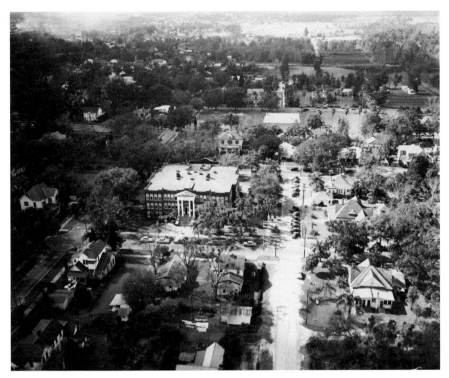

Aerial view of the Plant City High School constructed by the people of Plant City in 1914 to meet the needs of a rapidly growing community. Photo circa 1954.

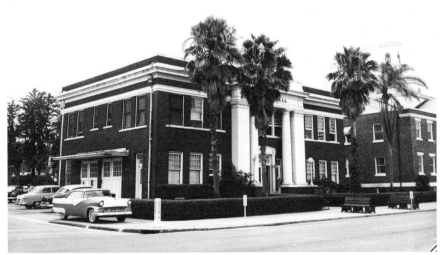

City hall, Plant City, Florida, about 1957–58. This building was constructed after the previous facility burned in the 1920s and it served until the 1960s. This building housed the administrative offices, meeting room, fire department and police department; the courtroom was on the second floor to the right.

## *Remembering* **Plant City**

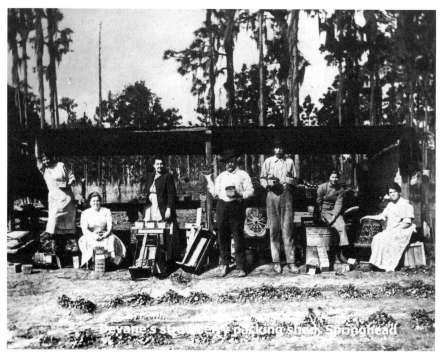

Devane's strawberry packing shed in the Springhead area, south of Plant City. Circa 1920.

almost a mile, waiting to get into the market area. In one day, the railroad shipped thirty cars of berries, containing over 500,000 pints, to points north.

Plant City was the hub of numerous civic and fraternal organizations, including Kiwanis, Lions, Knights of Pythias, Independent Order of Odd Fellows, Woodmen of the World, Masons, Board of Trade, Chamber of Commerce, Cemetery Improvement Association, the Draper Self-Culture Club, Women's Christian Temperance Union, School Improvement Association, the Woman's Club of Plant City, Rotary International and many more. Some of these clubs and organizations played major leadership roles in the future development of Plant City.

To accommodate travelers and tourists, there were several hotels in town, including the Victorian Hotel Colonial on the northwest corner of Reynolds Street and Evers Streets. Following the lead of the chamber of commerce, citizens organized and built the one-hundred-room Hotel Plant at the northwest corner of Evers and Reynolds, right across from the Hotel Colonial. Both were good vantage points from which to enjoy the annual Florida Strawberry Festival Grand Parade.

The Strawberry Festival had its beginnings as a board of trade Strawberry Day. The Lions Club decided to make it a big event and began organizing the first strawberry festival in 1929, with some assistance from the city. The

# An Overview of Plant City's Unique History

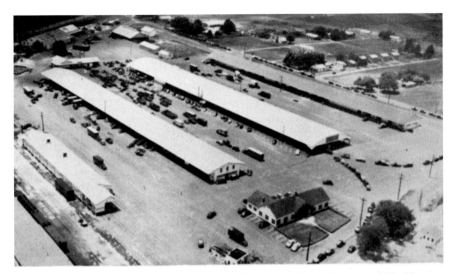

To meet the increasing need to help farmers market their produce, the state of Florida constructed a series of farmers' markets in various geographical locations in the 1930s. The State Farmers Market in Plant City was the largest one.

first of many festivals was held in 1930 in a vacant lot normally used for baseball, northwest of the corner of Baker and Michigan Streets. Except for the war years, 1942–47, the festival has been held every year, now running ten days and drawing about 800,000 visitors. It is staffed by hundreds of community volunteers.

Plant City has always been associated with physical activities, recreation and sports, and baseball stands out among them. From the Robinson brothers' baseball team of 1912 through the Buffalo Bisons, Indianapolis Indians, Miami Marlins, Texas Rangers, Cincinnati Reds and others, baseball has been the all-American pastime in Plant City. The baseball park once known as Ranger Field is now named for Mike Sansone, an Italian immigrant barber who worked tirelessly in support of Plant City area youth and American Legion baseball.

To this testimony to the community's civic pride and dogged determination, add the construction of the medical facility that became known as South Florida Baptist Hospital, completed in late 1953, and the building of the Bruton Memorial Library, which was dedicated in December 1960. The Bealsville community also continued to prove its mettle, and in 1932, by providing some financing and ten acres of land, was successful in getting the school district to build a school there, later named the Glover School. The school was active, and was expanded in 1945 and again in 1949, until the Glover School compound consisted of four buildings and a separate canning operation.

## *Remembering* **Plant City**

Industry has also fueled the development of the Plant City area, which benefited from the Warnell Lumber Company (1880s); Coronet Phosphate Company (beginning in 1908); Havana-Plant Cigar Factory (unfortunately now gone); Plant City Iron Foundry; R.W. Burch Company (citrus), owned by Lew J. Prosser, who also owned Plant City's first canning plant; and the opening of Florida's largest State Farmers Market in 1939. There were also Salada Foods, Plant Industries, Crystal Division, Paradise Fruit, Florida Sip, Trop-Artic Fruits (Breyers Ice Cream), Wishnatzki and Nathel (fruit brokers), Lykes Brothers, Mid State Potato, Acme Wellpoint, Southland Foods, Kilgore Seed, Plant City Steel and many others.

Since the erection of the 1914 high school, new high schools have been added: Marshall High School (then under E.L. Bing Jr., and now a middle school), the new high school building on Woodrow Wilson Avenue (now Mary Tomlin Middle School), the new consolidated Plant City High School and Durant High School, just to name a few.

Additions and expansions have also been made to the hospital and the library. The former downtown retail activity has moved south, and a renovated historic downtown has taken its place. Commercial and industrial activity continues apace, although traffic patterns have shifted due to the interstate highways, air transportation and better port facilities.

And a new city hall now stands as a tribute to the people of Plant City and two of the many leaders of this community: Nettie Mae Berry Draughon and Sadye Gibbs Martin.

# The Florida Strawberry Festival

The area of east Hillsborough County, Florida, that became Plant City has been an agricultural center since it was first settled. In addition to lumber and cattle, the area produced cotton, tobacco, corn, citrus and a number of other commodities.

Strawberries were introduced to the area in the late 1800s and they quickly became a leader in the farming areas. The soil of the Plant City, Dover and east Hillsborough County area was rich and fertile, and strawberries flourished there. By 1902 Plant City was evolving as the "Winter Strawberry Capital of the World."

By 1920, largely because of the transportation efficiency of the railroads, strawberries were shipped every day from December to May. Plant City was known as the largest inland shipping point in Florida, with fifty to sixty trains passing through daily.

Plant City's Board of Trade, a forerunner of the chamber of commerce, sponsored Strawberry Day as early as January 1914, and encouraged residents to mail postcards to friends and relatives to tell them of the succulent berries.

On July 5, 1929, Plant City Lions Club President Albert Schneider urged the club to sponsor a strawberry festival for the entire strawberry farming community. A committee was formed with City Manager John Dickerson as general manager, and the City advanced a loan of $1,000 for operating funds.

## *Remembering* **Plant City**

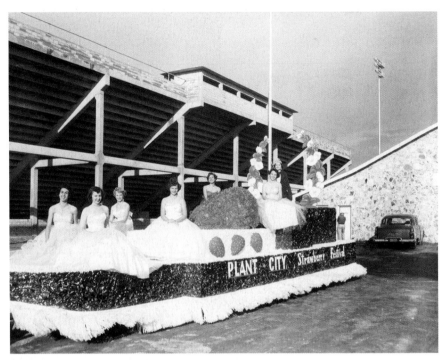

The Florida Strawberry Festival had its beginning in 1930 and has grown to become one of the largest in the country. Here the 1955 Strawberry Festival queen and her court are shown entering the festival grounds on their elaborate float.

An association was established and chartered, the festival received the approval from the state and the first Plant City Strawberry Festival was set for March 12–15, 1930. When opening day arrived, all exhibit booths had been reserved, and there was a waiting list. Every surrounding community joined in—Cork, Dover, Hopewell, Lithia, Pinecrest, Seffner, Turkey Creek—all participated. Area farmers brought to market 155,000 quarts of berries that day.

The first festival was held on vacant space that was frequently used for baseball and circuses, not far from downtown and east of the railroad tracks. A contest for festival queen was publicized in the *Plant City Courier* and the *Plant City Enterprise* and after all votes were in, Charlotte Rosenberg was elected Strawberry Festival queen. On opening day, the new queen and her court led the first parade through town to the festival grounds.

Adding to the celebratory tone of the festival, the local Business and Professional Women's Club sponsored a banquet Thursday night, followed by a fashion show skit on Friday night. The excitement in the air was palpable. The first day of the festival an estimated fifteen thousand people attended, and by the close of festivities some forty thousand had attended.

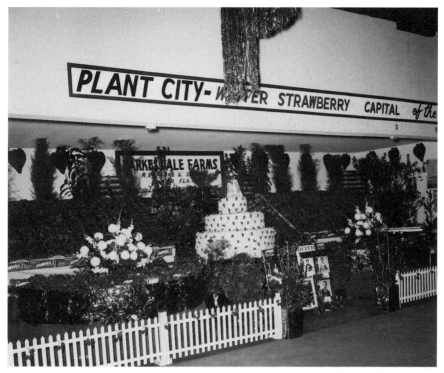

The central attraction at the Florida Strawberry Festival is strawberries in various forms—in shortcake or by the flat. This is the Parkesdale Farms booth shown at the 1966 festival.

The festival association worked hard and carefully planned each year's event, as they continued to grow in popularity and attendance, both in the number of visitors and exhibitors. The Midway was instantly popular the first day and grew every year. More events were added: arts and crafts, animal husbandry, the Baby Parade, the Grand Parade Luncheon and musical performances.

From 1930 on, the festival was held every year in late February or early March, until it was stopped short by the Second World War. The year 1941 was the last year for the festival until it was reignited by the American Legion in 1947 and the festivals began again in March 1948. The 1941 Strawberry Festival queen, Jane Langford, reigned until succeeded by Barbara Alley in 1948.

The festival, begun as the Plant City Strawberry Festival, grew and for a while was coupled with the Hillsborough County Fair. In 1962 it became the Florida Strawberry Festival. In 1976, with nationally known entertainers being brought in, attendance reached 150,000 people.

The festival continued to grow; it expanded territorially, enveloping block after block of an area west of the central part of the city. It acquired the

## *Remembering* **Plant City**

In addition to strawberries, arts and crafts, vendors, etc., the Midway, with its rides and amusements, is always exciting.

old stadium and surrounding grounds, the old Armory, American Legion and more.

By the year 2000, the Florida Strawberry Festival had grown to a ten-day event, including a Grand Parade that attracts 100,000 spectators; a multitude of exhibitors; a virtual tent city; several entertainment tents; a major entertainment stage with internationally acclaimed performers; parking by the busloads and a shuttle service; hundreds of thousands of strawberries and tons of strawberry shortcake; hundreds of local volunteers; and attendance that has reached approximately 800,000 people.

From a boast of a proud citizenry in years past, the festival has now evolved into one of the top events in the country.

# The Grand Parade
*A Plant City Spring Tradition*

By the end of the second decade of the new century, the small town born of the railroad on January 10, 1885, had already earned the reputation of the "World's Winter Strawberry Capital." The strawberry was now king. To promote the surging strawberry business, the Plant City Board of Trade sponsored a Strawberry Day as early as 1914, but the first Strawberry Festival was not until 1930, and a grand one it was.

The first festival was staged on vacant land north of Baker Street and west of Michigan Avenue, near the tracks. Part of the marketing of the first festival was the selection of a queen and her court, and on opening day of the festival, Wednesday, March 12, 1930, the new queen and her court led the parade of elaborately decorated cars and floats, some horse-drawn, through the business district and up Michigan Avenue to the festival grounds.

Gaiety was in the air and for most people it was great fun, but there was a heightened competition for the float builders. The ornate floats were to be carefully judged, and prizes were awarded at the festival. The float built by G.R. Roberts garnered first place. Second place was awarded to the Plant City kindergarten float, and the Business and Professional Women's Club took third.

The festival and the Grand Parade grew in popularity each of the succeeding years. World War II, however, put an end to the festival in the

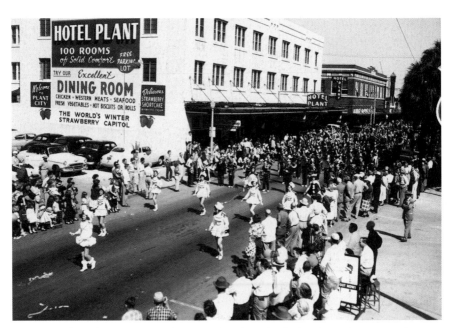

The Grand Parade has been a major attraction since the festival began in 1930, and marching bands have always provided moments of music and excitement, such as this high school band entertaining the crowd at the 1954 festival parade.

years 1942 to 1947. In 1947, the Norman McLeod American Legion Post, whose membership was swelled by the numbers of returning veterans, took over the job of reviving the festival. The renewed festival was staged in 1948 and has run every year since, with the parade being a special feature for every area resident and the many visitors, young and old.

Traditionally, the parade forms outside the downtown area and proceeds through the downtown and west on Reynolds Street to the festival grounds. As it proceeds, hundreds of spectators line the streets, some with their chairs, some on foot, in carefully parked pickup trucks, peering out the windows of downtown buildings and some on the roofs.

Then the parade moves through the residential area, where almost everyone seems to have a party of some sort going on—in yards, on porches and along the walkways. Parade participants wave and throw beads and candy, and walkers greet the excited spectators who are waving and calling for treats. Every float seems to have music—some have bands—and the marching bands are all playing their best to outshine all the others. After the floats, cars, marchers, etc., the magnificent horses—Paso Finos, quarter horses and horses of all breeds and colors—all with colorful equestrians aboard, complete the long passing of the Grand Parade.

# The Grand Parade: A Plant City Spring Tradition

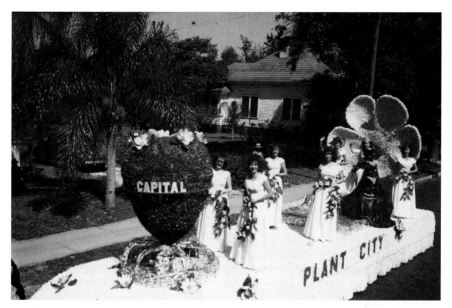

The crowning touch of each Grand Parade is the official festival float with the Strawberry Festival queen and her court. This photo shows the 1950 queen en route to the festival grounds.

Along with the Baby Parade, the renowned entertainment, agricultural exhibits, arts and crafts, the Midway and countless vendors of the Florida Strawberry Festival have all become an attraction of immense proportion. But the Strawberry Festival Grand Parade still stands above all the rest.

With over one hundred entries, including the new queen and her court, numerous clubs and organizations, schools and marching bands, businesses, politicians of every sort and dozens of miscellaneous groups, the Grand Parade easily draws over 100,000 spectators. And then there are breakfasts, lunches and countless parties that precede and follow the parade. The Grand Parade has become an official holiday in this part of the world.

# The Baby Parade

What would the Strawberry Festival be without the most unusual and strangely interesting event of the whole festival—the Baby Parade? This isn't the big magnet that draws thousands from Maine to California, and farther. This isn't the headliner that most of the festival crowds attend. It is just the most wonderful event that takes place for area residents with or without their own children entered. It has an aura all its own.

The festival itself began in 1930 and the baby events began in 1931. That year the king and queen of the Baby Parade were Jack Peacock and Mary Mike (Jack became one of the most respected doctors in town, and Mary Mike's father, Tony Mike, was well known as the purveyor of fine spirits). They were idyllic. And we have seen many more wonderful young couples follow suit.

It is quite possible that so many attend the Baby Parade just to take in all the creativity on display. From elaborate floats with shiny pianos, flowers, creative sets and detailed costumes, to children walking with their beloved animals—it's all there. Children dressed like Liberace, Humphrey (from Li'l Abner fame), Miss America, future farmers, swimmers, boaters, homemakers, beauty queens, men about town, Uncle Sam, clowns, acrobats, cheerleaders, pilots, dogs and more dogs, horses and cowboys and, well, they're all there. And these are some of the most adorable little children that you've ever seen.

# The Baby Parade

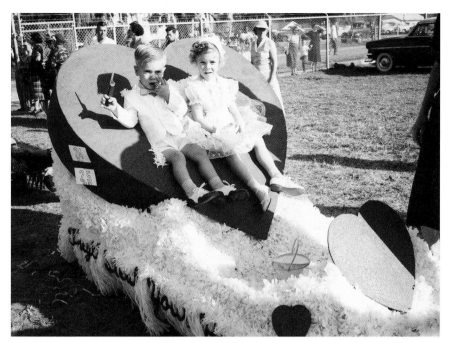

This young couple enjoys their valentine ride on a heart-fashioned float in the Strawberry Festival's 1955 Baby Parade, a very popular event of the festival.

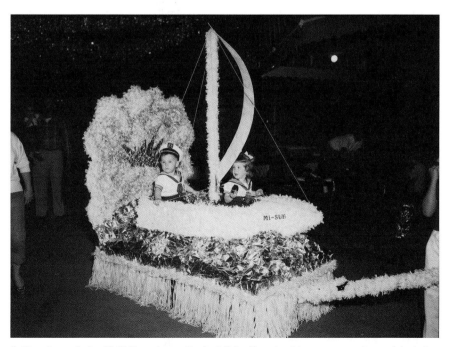

Sailing through the 1956 Strawberry Festival Baby Parade, this young couple models their nautical attire to a bevy of onlookers.

## *Remembering* **Plant City**

Ruby Jean Barker (Redman) participated as a cute young tot in several baby parades and was later a Strawberry Festival Queen. Dub McGinnes (later president of McGinnes Lumber and Stock Lumber) was in a parade also, in his structure "Built by Dubby Destruction" in 1950. And there was the young "Just Married" couple, Pec Chambers (who later married Dub McGinnes) and John Kilgore, with the Kidde Kar headed for Niagara Falls.

Plant City Photo Archives has over one hundred photos of children in the Baby Parade, including Jackie Pinson (Everidge) of the Miss America float in the 1949 Baby Parade; two cupids riding on hearts in the 1955 parade; the 1956 king and queen innocently kissing on their throne; an adorable little girl, a dapper young man and a future farmer, all in the 1956 parade; and a commodore and his mate sailing through the 1958 parade along with a spry young aviator. Ya gotta love it. These kids are wonderful—and you can imagine how much love and effort their parents put into these wonderful events.

That's it. The Strawberry Festival Baby Parade. Hope some of you enjoyed seeing the parades in years past, and we know everyone will look forward to the procession of these enthusiastic youngsters in future Baby Parades.

# The World's Largest Strawberry Shortcake

Plant City, Florida

February 19, 1999

If nothing else, everyone knows that Plant City is known for its strawberries. So it came as a surprise that, while during a Greater Plant City Chamber of Commerce planning session in the fall of 1998, someone discovered that Watsonville, California, had held the record for the world's largest strawberry shortcake, but that it now was held by a city in Canada. It was a disgrace. Plant City certainly should have that record. Planning began.

A committee was formed and the decision was that the Greater Plant City Chamber of Commerce was going to reclaim that honor, and the announcement was proudly made. Other more pressing matters intervened, however, and the project drifted to a state of inactivity. In late December the situation was revisited and it was recognized that the project was far off schedule.

In January 1999, a reorganized committee began in earnest and quickly amassed a cadre of volunteers who had experience in logistics, public affairs and other needed areas of expertise, including construction, resources, planning and scheduling. Meetings were held feverishly, determining where the strawberry shortcake was to be constructed, on what platform, where to acquire the berries, the cakes, the whipped cream, what teams would be necessary to perform the many tasks and on and on.

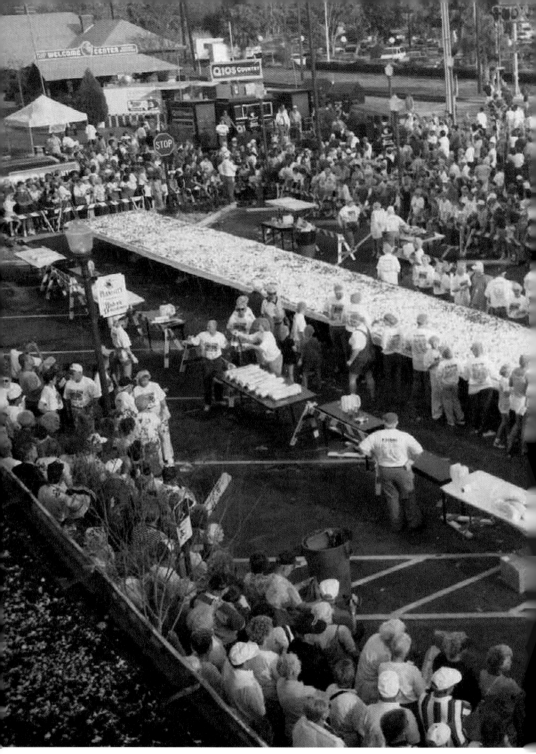

Plant City has claimed the title of "Winter Strawberry Capital of the World" since the 1900s. On February 19, 1999, the Greater Plant City Chamber of Commerce organized hundreds of volunteers to construct the World's Largest Strawberry Shortcake. At 8 by 102 feet, the shortcake was entered into the *Guinness Book of World Records*.

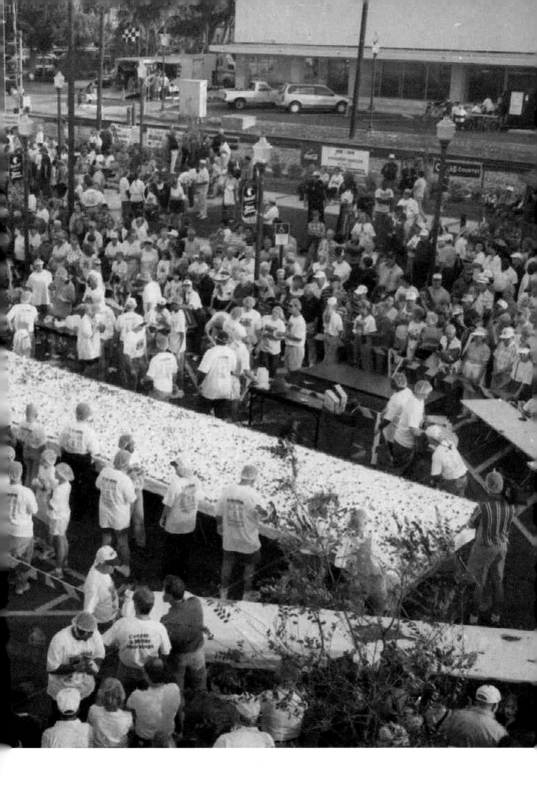

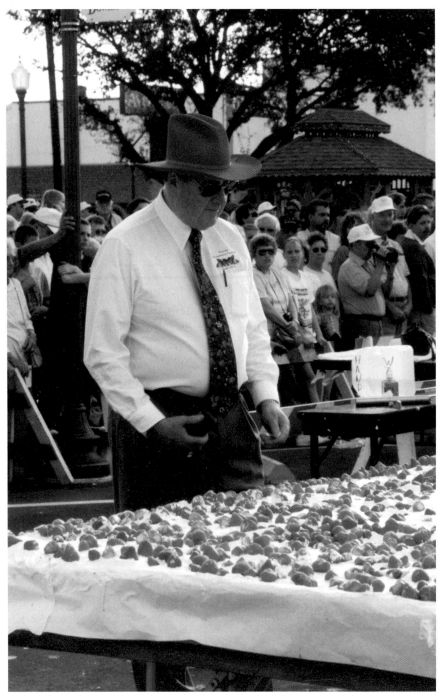

World's Largest Strawberry Cake Committee Chairman B.M. "Mac" Smith, of B.M. Smith Motors, prepares to cut the first slice of the over eight-hundred-square-foot strawberry shortcake.

# The World's Largest Strawberry Shortcake: Plant City, Florida, February 19, 1999

The center of town was selected, next to McCall Park across from the old Union Station, now a Visitors Center, and a street that could be blocked off. The police and fire departments were brought in, and contacts were made with the State Department of Health, the Department of Business Regulation, the people at the *Guinness Book of World Records*, the city's engineering department with their laser surveying equipment and area storekeepers. A vacant storefront was obtained for supplies and operations, and the Union Station was set up for volunteer organization.

Then there was the negotiation with the Florida Strawberry Growers Association, local branches of major supermarkets and vendors at the State Farmers Market. A stemming area had to be acquired and transportation had to be arranged. The construction of the 104-by-8-foot table was already in process. It was to be constructed of 4-by-8 plywood sheets, thirteen in length and two across, and covered with a food service–quality poly-plastic. Things were coming together by the end of the first week of February, but February 19, the target date, was closing in. A CPA firm agreed to audit the entire process and attest to its accuracy, and a federal judge agreed to authenticate the findings. The Health Department would oversee the quality of the food handling and the city engineer would sign off on the exact measurements.

Even before the first ray of light came over the horizon early that Friday morning of February 19, 1999, the berries were waiting for the stemmers at St. Clement's Catholic Church's cafeteria. The volunteers, over 150 of them that morning, began streaming in and by dawn the stemming tables were humming as runners tried to keep up with the stemmers. Area strawberry growers, through the Florida Strawberry Growers Association, had donated the strawberries for this event—all 480 flats!

From the stemming tables, runners carried the berries to the processing area, where the volunteers added the sugar (five hundred pounds donated by Crystals International), processed the berries and filled 107 five-gallon containers. They were loaded onto a Winn-Dixie refrigerated trailer and taken to Winn-Dixie Superbrand Dairy, where the whipped topping was loaded, and the semi-tractor and trailer made its way to McCall Park, where an army of volunteers awaited.

At exactly 4:00 p.m. the trailer doors swung open and the multitude of cake carriers, berry spreaders and whipped topping spreaders launched into their tasks: 678 half-sheets of shortcake (courtesy of Winn-Dixie) were covered with 3,500 pounds of processed berries and 40 cases of whipped topping, and then another 45 flats of whole berries were added. The cake was 102 feet long and weighed over 8,000 pounds.

The volunteers, over three hundred in all, finished their monumental challenge in just under thirty-five minutes, and the official survey was begun. At 5:00 p.m., B.M. "Mac" Smith, chairman of the World's Largest Strawberry Shortcake project, proclaimed a new world record of 827.44 square feet! At 5:15 p.m. the gates were opened and thousands of pieces of shortcake were served to the crowd, hungry for shortcake and a piece of history.

Thanks to the wonderful strawberry growers, Winn-Dixie and the hundreds of volunteers, Plant City was recognized as the world record holder in June of 1999, and was listed in the 2000 publication of the *Guinness Book of World Records*.

# The Plant City Christmas Parade
## A Tradition and a Treasure

As many small towns do, Plant City goes all out for its annual Christmas Parade. Maybe even more so than most, for this parade has been called the largest of its kind in Florida.

A unique twist to the Plant City Christmas Parade is that every year Santa Claus's arrival is a secret until the parade itself. Although everyone knows Santa Claus is coming to town, no one is quite sure when and how he will arrive.

On December 1, 2006, thanks to the local National Guard Armory, Santa rode into town on a ten-ton heavy expanded mobility tactical truck, known as a Hemitt. It was also a tribute to the Plant City National Guard's Fifty-third Infantry Brigade, who arrived back home on November 11 after a year in Afghanistan.

The overall parade was an hour and a half long, and included more than 135 units: floats, marching bands, local clubs and organizations, public officials and other notables. More than fifty thousand spectators turned out to watch.

By 1950 the Christmas Parade had already become a tradition, and its appeal had become a treasure. In 1950 the parade was on Saturday, December 16, and Santa was to arrive that afternoon. On Friday, December 8, 1950, the *Courier* stated, "Just how Santa will arrive remains a secret but it will be about 2 o'clock and he will be serenaded by the

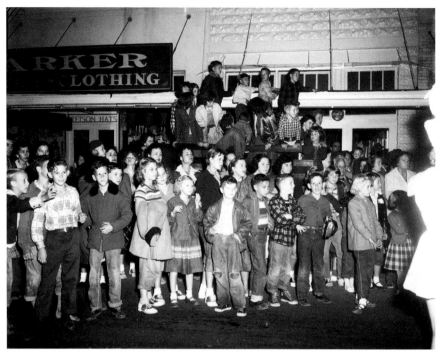

The annual Plant City Christmas Parade draws thousands of spectators to the display of decorated cars, trucks, ornate floats, marching bands and, as anticipated, the surprise arrival of Santa Claus. This photo is from the 1954 parade.

junior high school band. After a short parade he will go to City Hall Park to spend the rest of the afternoon as host at a party for children."

The parade was short then, focusing on Santa and the party at City Hall Park (also known as central park). The following week, continuing the spirit of excitement, the *Courier* carried another article announcing the impending visit:

> *Old Guy With Whiskers Will Greet Kids On Collins Street*
> When Santa Claus comes to Plant City Saturday afternoon at 2 o'clock his method of travel will be different from anything else he has ever ridden in or on. It isn't definite where Santa will make his first appearance but he will parade around the business district accompanied by the junior high school band, majorettes, and cheer leaders.

When Santa arrived, it was cold. East Hillsborough's unusual long-underwear weather put a crimp in the 1950 Christmas program, causing two of the scheduled outdoor events to be moved to the high school auditorium two blocks north of City Hall Park. Christmas spirit prevailed,

# The Plant City Christmas Parade: A Tradition and a Treasure

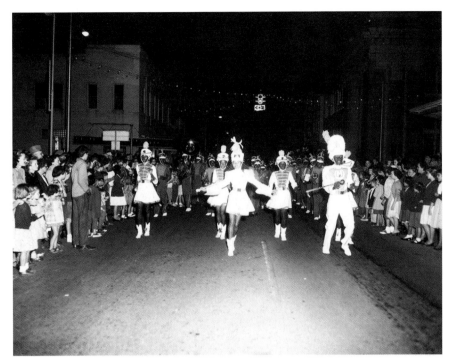

The 1954 Plant City Christmas Parade included the exciting performance of the Marshall High School Band.

however, and 3,200 youngsters welcomed Santa as he arrived in a vintage restored 1892 Haines automobile, owned and driven by L.W. Whitehurst.

In 1955 the parade was at night and the weather was cold, but not as frigid as it had been in 1950. Several trucks were borrowed from McGinnes Lumber Company that year, and when Santa Claus made his appearance he was riding on the back of a McGinnes Lumber Company flatbed truck, standing near a fireplace and accompanied by a group of children snuggled in their blankets.

The 1958 Christmas Parade was held on a Thursday night, December 18, beginning at 7:00 p.m. It formed south of downtown, proceeded through the business district, circled several blocks and headed to the new county courthouse. There was no party because the City Hall Park had been converted into a parking lot. The parade signaled the beginning of the holiday season and marked the beginning of evening store hours for holiday shopping in the downtown shops. That year Santa arrived on a green-and-white float decorated with two large gold horns of plenty, greeted with shouts of joy and hand waving.

Christmas Parade night in 1961 was another cool clear night and, as usual, a large crowd, which increased every year, braved the cold to watch

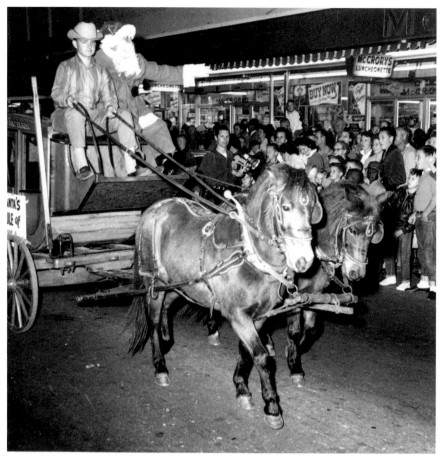

Making his surprise arrival on a horse-drawn carriage, Santa waves to the crowd of onlookers as he passes McCrory's department store in the 1961 Christmas Parade.

the floats and marching bands and to greet the arrival of Santa. That year, Santa made his grand arrival on a Pony Express carriage drawn by a team of horses festooned for the holiday season. The parade has now been moved to the first Friday evening in December and consists of upward of one hundred floats, marching bands, etc., and continues to draw ever-growing numbers of spectators.

# African Americans in Plant City

African Americans have been part of Plant City, Florida, since the earliest days of the community. They have played many important roles, especially in education and community building, and here is just some of that history.

## *Bealsville*

The Bealsville community outside Plant City is unique in American history for the way it was organized, and it predates the city itself. Peter Dexter, one of the founders of Bealsville, was born in Georgia and moved to eastern Hillsborough County in the late 1840s to work the plantations. When the Hancock, Berry, Hamilton, Branch, Wilder and Howell Plantations freed their slaves in 1865, a number of families remained on the Howell lands to plan their future settlement. Those twelve original families were those of Peter Dexter, Bryant Horton, Roger Smith, Robert Story, Isaac Berry, Mills Holloman, Sam Horton, Mary Reddick, Jerry Stephens, Neptune Henry, Steven Allen and Abe Sesenger.

Dexter, who had acquired surveying skills, and Smith, Stephens, Reddick and Horton searched for and selected prospective home sites. Through the Southern Homestead Act of 1866, families were able to homestead property ranging from 40 to 160 acres. The community, which was originally called

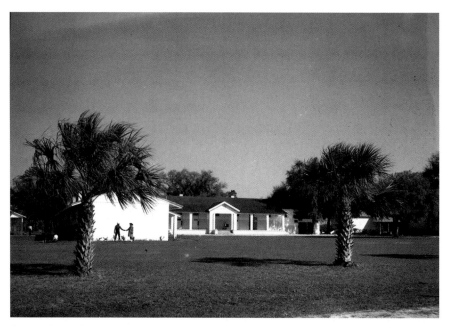

Continuing its focus on education, the black community of Bealsville built this school in 1933 with the support of local resident William Glover. It served the Bealsville and Plant City communities for nearly fifty years; it was closed in 1980.

Howell's Creek and later Alafia, founded Antioch Baptist Church in 1868 and almost immediately set up a school within it, with William Glover procuring the first teacher. The land for the church, school and a cemetery was donated by Alfred Beal and in 1923 the community was named Bealsville in his honor.

Beal was also noteworthy for setting a precedent of keeping Bealsville property in the hands of local families. If a property owner defaulted on mortgage or tax payments, Beal would buy the property and sell it back to residents in smaller parcels.

## Willam Glover School

With its traditional focus on education, the black community of Bealsville built a one-room schoolhouse, Antioch School, in 1873. Unable to get the school district to build a new school, in 1932 Bealsville residents raised $1,000 and William Glover donated ten acres of land for the school. This time the school district said yes, and a three-room wood-frame building was constructed in 1933 and was named the William Glover School the following year. The school was expanded in 1945 and again in 1949; the Glover School then included four separate structures.

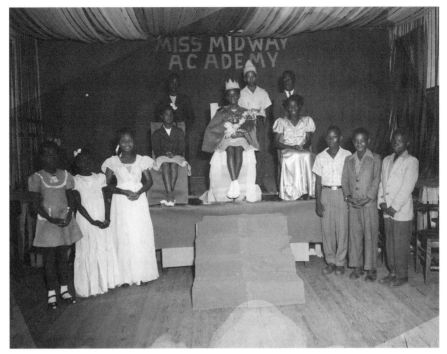

To serve the African American student population in Plant City, an elementary school, Midway Academy, was built about 1920. It grew until the late 1940s, when the high school grades were separated and became Marshall High School and the lower grades became Lincoln Elementary. This photo of Miss Midway Academy was taken in 1947.

The Glover School, a "Strawberry School" (i.e., closed during strawberry picking season) until 1962, has held a special spot for many in the Bealsville community over the years and served the black community until 1972, when it became a sixth-grade center, serving both black and white children. Over time, the old school became obsolete and was closed in 1980; in 1981 it was donated back to the community, whose area residents had formed a nonprofit organization, Bealsville, Inc., to preserve it. Today (2007) the Bealsville Glover School sits proudly on Horton Road, just a short distance southeast of Plant City, as a historical site; it is also used for programs for the elderly and for several other community programs.

## Midway Academy to Marshall High School

With a growing black community settling in the Lincoln Park area in the southeast sector of Plant City, an elementary school was built there in 1920. It was named Midway Academy and at first served grades one through eight. Beginning in 1936, one additional grade was added each

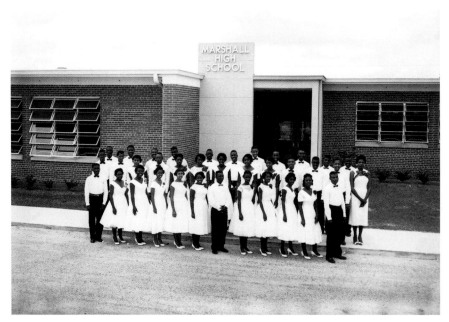

The old Midway Academy building continued to serve the new Marshall High School (established in 1949) until this new school was constructed in 1957–58.

year until all grades through twelve were being taught. It was at this time that the Plant City Negro High School came into being. In 1949 the name was changed to Marshall High School, after Supreme Court Chief Justice John Marshall.

A new Marshall High School was built in 1957 on a thirty-acre tract of land on Maryland Avenue, a few blocks north of the old school; the former Midway Academy had been renamed Lincoln Elementary, and a new building had been constructed. In 1972, in accordance with the school district's integration plan, Glover School became a sixth-grade center and Marshall School became a seventh-grade center. Fittingly, the man who was principal at Marshall High School from 1954 to 1967, E.L. Bing Jr. of Plant City, served as the school district's director of federal projects and was credited for the smooth integration of the public schools.

## The Bings, the Seminole Restaurant and the Rooming House

The Bings are a well-known Plant City family. The progenitors, Janie Wheeler and Elijah L. Bing Sr., were from other areas, Alachua County and South Carolina, respectively, and met in Plant City about 1917–18 and married

shortly thereafter. They built a structure on East Laura Street about 1925 and operated the Seminole Restaurant there until 1955. On the north portion of the same lot, they constructed a house facing Allen Street that became the Bing Rooming House, which served the African American travelers, visitors and local area residents in a segregated society. Janie Wheeler Bing operated the Bing Rooming House at 205 South Allen Street (in Lincoln Park) for nearly fifty years, from the 1920s to about 1975. The Bings were well known for the quality of their hospitality—clean rooms and good food—and the people who stayed and ate there included teachers, lawyers, ball players, ministers and other prominent people. Baseball Hall of Fame's Frank Robinson was among the many who enjoyed the Bings' establishments.

The restaurant building has been razed, but the house still stands. It hasn't changed much. It is now owned by the Plant City Improvement League and is recognized by the city of Plant City and the state of Florida for its historic significance. The Improvement League is currently restoring the historic building. James Washington, the son of Mildred Bing Washington Majors, was born and raised in the old rooming house and continues to reside there.

# The Plant City Chamber of Commerce at Eighty Years

Early businessmen in Plant City met and organized a board of trade to promote the city's industry and growth potential. Little was actually accomplished, although the board retained an office on North Collins Street in the Wells Building in the center of the downtown area. About 1911, Wayne Thomas, who bought the newspaper the *Plant City Courier*, was critical of the non-functioning board and proposed to change it.

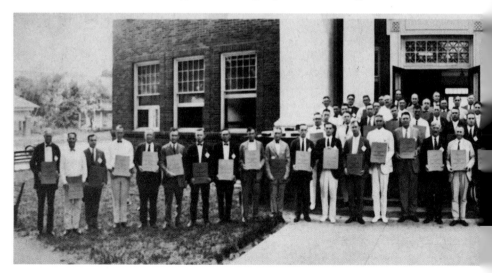

# The Plant City Chamber of Commerce at Eighty Years

Thomas and a number of other businessmen and their spouses formed a Plant City Boosters organization to promote the city and traveled to Chicago and other cities to spread the news about Plant City. By 1912 a new group took over the board of trade, and Thomas served as vice-president. It was still slow going. In 1913 an all-out effort was made to revive the foundering organization and the successful membership drive increased membership from fifty to three hundred. By 1924, this organization, too, was faltering.

Plant City's Chamber of Commerce, now called the Greater Plant City Chamber of Commerce, traces its direct roots to the previous organizations, but specifically to August 1924 and an effort by the Kiwanis Club to revive the defunct board of trade. The Kiwanis Club, Plant City's first men's civic club, was formed in 1921 and had among its members most of the town's prominent business and professional men.

W.E. Lee, mayor of Plant City (1920–1925), called a meeting to organize a board of trade. An organizer from the Florida Development Board was brought in from Jacksonville to direct the membership drive and a mass meeting was held in the 1914 Plant City High School auditorium. Mr. Vivian B. Collins (stepson to Dr. Olin Wright and son of Palestine Collins Wright) was the local director of the membership drive, and Tom J. Knight was assigned ten team leaders who would compete with each other in signing up members. They would meet and report daily at 1:00 p.m. at the Hillsboro Café, not far from city hall.

In the one-week membership drive 492 members were signed by teams led by J.E. Cassels, V.B. Collins, E.J. DeVane, H.J. Haeflinger, A.R. Larrick, T.E. Moody, R.M. Morgan, W.R. White, G.H. Wilder and Henry Kilgore. It was an outstanding success.

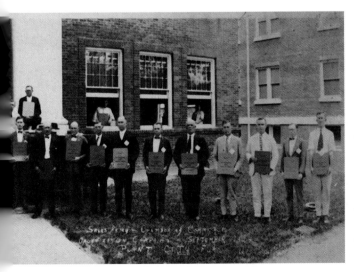

After completing a very successful membership campaign, signing up nearly five hundred members to the new East Hillsborough Chamber of Commerce, the "Sales Army" poses in front of the Plant City City Hall in September 1924.

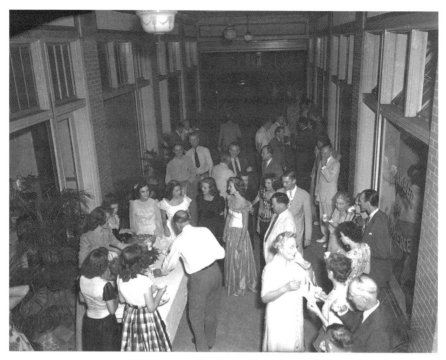

The chamber of commerce fell into a lull after the Great Depression hit. Following the close of World War II the chamber was reinvigorated and moved into new office space in the elaborate Wright Arcade. This photo is of the official reception for the newly hired secretary in 1947.

The first organizational meeting was held in the high school auditorium on October 3, 1924, where they drafted a constitution and bylaws. The new organization was named the East Hillsborough Chamber of Commerce. By the end of the following week, the organization had elected ten directors: Collins served as president; Dr. Alsobrook was first vice-president; Larrick, second vice-president; and Morgan, treasurer. They then hired a professional secretary, Mr. J.C. Jenkins from Indiana, who set up office on November 18, 1924, at the chamber's new quarters at the corner of Reynolds and Evers Streets.

The chamber's first project, building a new hotel, required a great deal of cooperation and coordination, and was hugely successful. Two years later, on November 11, 1926, the beautiful Hotel Plant held its grand opening, and the first major event took place only one week after opening. It was the chamber's annual banquet.

With the Great Depression, the chamber's activities waned and they could no longer afford a professional manager. Arthur Boring, assistant cashier at Hillsboro State Bank and a city commissioner for six years, and

# The Plant City Chamber of Commerce at Eighty Years

Henry Huff, an officer with the Strawberry Festival Association, became unpaid officers of the chamber and kept it running out of Huff's auto tag agency in the Hotel Plant.

After World War II came to a close and economic conditions improved, interest in the chamber increased to the point of seeking a full-time professional secretary to manage it. In 1946, William Barbour of Franklin, Pennsylvania, was hired. Upon his arrival, Plant City welcomed Bill and Kathryn Barbour in style, with private luncheons for each and a grand public reception in the Wright Arcade, where the new chamber offices were located.

The chamber was reinvigorated and has continued to promote the greater Plant City area to this day. The name was changed to the Greater Plant City Chamber of Commerce and the offices were moved first to the east side of town and then, about 1994, to the vacant McCrory's Building on Evers Street in the downtown central business district, where it also houses the Plant City Economic Development Council. In 2004, the chamber celebrated its eighty years as a chamber of commerce.

# Pioneering Families
## *Hawkins Corner*

This is a story about one of the pioneer families of the fertile Plant City area. Richard Skinner and Martha Sue Ellen Hawkins Skinner live on the old Hawkins homestead, known to most everyone in Plant City as Hawkins Corner, located just off the southwest corner from the intersection of State Road 39 and Trapnell Road, just a short distance south of Plant City proper. Martha Sue was born on the Hawkins property and she lived there until she was nine years old. In 1951 her father moved his young family to Miami.

Martha Sue is a descendant of some of Plant City's earliest settlers and is a seventh-generation Floridian. Her lineage can be traced back, thus far, to the 1830s. On the eighth day of October 1838 in Mineral Springs, County of Columbia, Territory of Florida, forty-five men signed the official petition for the purpose of forming a state constitution. Among the men were several generations of Martha Sue's family: Thomas Hawkins, who was married to Nancy Sharpe (daughter of Joshua Sharpe); Joshua Hawkins (the oldest son of Thomas and Nancy Sharpe Hawkins); and Joshua Sharpe. Florida was recognized as a state on March 3, 1845.

In 1844 her great-great-great-great-grandfather Reverend Samuel Knight moved from Columbia/Alachua County, Florida (Alachua County was later cut from the larger county of Columbia), to what was then known as the Ichepucksassa (also spelled Hichipucksassa until the post office changed

# Pioneering Families: Hawkins Corner

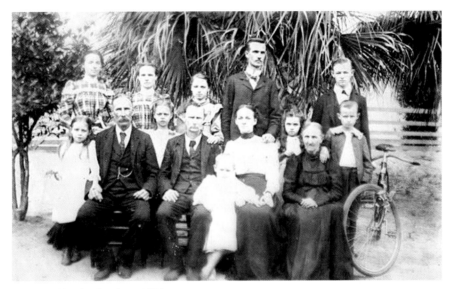

The Hawkins family about 1899.

it to Ichepuckesassa, and later to Cork) area, now known as Plant City. He homesteaded Knights Station and, being a Methodist minister, he established the first church in Plant City.

Reverend Samuel Knight's oldest daughter, Fatima, married Enoch Collins (after whom Collins Street in Plant City is named). Fatima was the first of his three wives, with whom he had twenty-nine children. Enoch Collins is Martha Sue's great-great-great-grandfather.

Martha Sue's great-great-great-grandfather Thomas Hawkins, who had homesteaded a four-thousand-acre estate in Suwannee County, never moved to Plant City. It was his son, Martha Sue's great-great-grandfather John Wesley Hawkins Sr. (1826–1878), who came here in 1855 on an oxen-drawn wagon when this area was known as Ichepuckesassa. He married Eliza Collins (1829–1910), the oldest child of Enoch and Fatima Collins. John Wesley and Eliza homesteaded a large portion of the property that ran from the southeast corner of State Road 39 and Trapnell Road, across the highway from where Richard and Martha Sue reside today.

Martha Sue notes that life was seldom easy for John and Eliza, but Indian uprisings proved to be the most difficult times for them. Angry and vengeful, the Indians would converge upon the homes of the settlers to take whatever they could, however they could. Many times they beat the settlers and their families and stole their children to make slaves of them.

One afternoon, while alone at home with her children, Eliza was hoeing in the garden and looked across the clearing to see Indians coming out of the woods. She reacted quickly by grabbing her two

A copy of the petition signed October 8, 1838, in Mineral Springs, Columbia County, Territory of Florida, where forty-five men signed the official petition for the purpose of forming a state constitution. Three of those who signed the petition were members of the Hawkins family.

## Pioneering Families: Hawkins Corner

Built in 1903, this was the first house constructed on the Hawkins lands, located on State Highway 39, south of Plant City. Pictured here in 1915 are Lois Hawkins and Stephen Ellis Hawkins.

children, running with them into the house and hiding them in trunks. The Indians came into her house, ransacked it, took what they wanted and left without ever knowing that there were children in the house. So it was that during the third Seminole Indian War John Wesley Hawkins Sr. joined the United States cavalry (mustered in December 1, 1855, and mustered out January 1, 1860) and served as a private in Captain S.L. Sparkman's company, Mounted Volunteers.

John Wesley and Eliza's son, John Wesley Hawkins Jr., married Sarah Rebecca Sparkman. They homesteaded an area of land on the east side of State Road 39 that now sits between Sparkman Road and Kilgore Road.

John Wesley Hawkins Jr. and his wife Sarah had five children: Lillian, Stephen Malathron, Marvin, Byrd and Ella Ethel Hawkins. In 1885, to the family's grievous misfortune, John Wesley, who had been out to help with a barn raising, got caught in a heavy, cold rain on his way home. He died from pneumonia a few days later, on May 15, 1885, at the young age of thirty-four. Three months later, tragedy struck the Hawkins's home again when on August 8, 1885, little seven-month-old Ella Ethel passed away.

The site where Martha Sue now lives was once owned by the Virginia Railroad Trust. The State of Florida had given the land to the trust. The Virginia Railroad Trust eventually sold the land to the Warnell Lumber

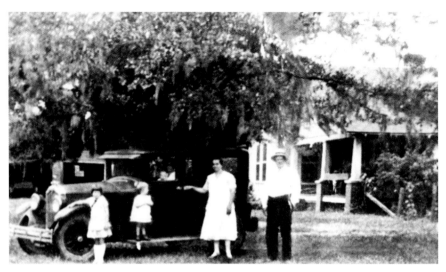

The Hawkins homestead on State Road 39 south of Plant City as it appeared in 1928. In the photo are Irma Hawkins, Freda Hawkins, Lois Hawkins Maxwell, her baby Jane Maxwell, Ellen Tomberlin Hawkins and Stephen Malathron Hawkins.

Company for its timber. The Warnell Lumber Company hired farmers and men from the area for its operations, the wage being a dollar a day. The company paid the workmen at the end of each day, giving them the option of taking their entire earnings or placing some of it in escrow.

Following the death of his father, Stephen Malathron Hawkins stepped into the role of supporting his mother and his siblings; he was one of the young men who acquired a position with the Warnell Lumber Company. And with dreams of a life with the woman he wanted to marry, Miss Ellen Tomberlin, he opted to take fifty cents a day, leaving the remaining fifty cents in an escrow account. Around 1902, when the Warnell Lumber Company had finished clearing the land, Stephen Malathron Hawkins was able to purchase eighty acres from the company. In 1903 Stephen and Ellen Tomberlin Hawkins built the first of their two homes there. Martha Sue affectionately refers to Hawkins Corner as "Dollar Acres," because her grandfather paid one dollar for each of the acres.

Stephen Malathron gave to his only son, Stephen Ellis, a portion of his property that sits to the west of State Road 39, on the south side of Trapnell Road, less than a half mile from his residence. Some of that land had been farmed, but the majority of it had been left to reforest itself. It was through a barter system that young Stephen Ellis was able to build a lovely home there in 1930 during the Depression.

Enlisting the help of one of his cousins, Stephen Ellis struck a deal with the owner of a local sawmill. Through this, he managed to build his home,

which still stands today, with beautiful grains of timber. It was on this property that Stephen Ellis planted his first orange grove.

Stephen Ellis Hawkins married Carabelle Morton. They had two children, Carolyn Faye and Martha Sue Ellen. Surrounded by loving family members, the four of them treasured their home and ways of life in Plant City until Martha Sue was nine years old. In 1951, because of his position as an investigator with the immigration service, Stephen Ellis was transferred to Miami, and he and his family had to leave their home, their relatives and their friends behind.

Stephen Ellis's older sister, Lois, married Goldston Maxwell. His sister Sarah Irma married John C. Herring Sr., and his sister Freda married Ed Stubbe. The properties on all four corners of State Road 39 and Trapnell Road are still owned by heirs of the founding Hawkins family.

Richard Skinner and Martha Sue Ellen Hawkins were married on February 4, 1961. Compelled by her family's deep, historic roots in Plant City, she, along with her husband and her children, moved back to her birthplace in 1980. With dreams of sharing their lives together on the property that was homesteaded by her grandfather, Stephen Malathron Hawkins, she and Richard rented temporary housing and began planning and preparing to build a new home for their family.

Richard Skinner, a salesman, decided that he was going to build their new home himself. And although Martha Sue jokingly comments now that the only thing Richard had ever built was a rabbit pen, from which the rabbits had continually escaped, she had great faith in her husband and his abilities. In 1982, with the help of his son Mark and from some of the Skinners' friends, Richard did indeed build the large, beautiful and charming two-story log home that now stands on the site of Martha Sue's grandfather's old home place.

Richard and Martha Sue have three children—one daughter and two sons. At the time of Martha Sue's return to Plant City, her daughter Kerri was going off to college, Mark was in the eighth grade and six-year-old Kenneth was in the first grade. After settling into their new home, encouraged and mentored by Mrs. Quintilla Bruton and given much support by Richard, Martha Sue began researching her family's past. Having remained diligent through the years in her explorations and inquiries, she has gathered facts, photos and documents for the sake of preserving some of Plant City's valuable pieces of history. These are items that may otherwise have been lost and forgotten.

Richard and Martha Sue are grateful and giving people. They maintain their home and property with great affection as they walk among the memories that linger there. They hold in high regard the hard work,

diligence and sacrifices made by her ancestors, who paved the paths that they now live and walk upon. They have put forth much effort to collect, preserve and make known some of the rich history that breathes through the Plant City area. They love one another deeply, and they endeavor each day to give something back to the town they chose to make their own.

(An interesting note of history: State Road 39 was once a narrow dirt road called Hopewell Road. It became known as State Road 39 around 1960.)

Martha Sue says:

> *My fourth great-grandfather, Reverend Samuel Knight, had ten children; my third great-grandfather, Enoch Collins, had twenty-nine children. So, just through their lineage I am related to many folks in these parts. So, I have to be careful who I might have a slight difference of opinion with, because if they, too, can trace their lineage to early Plant City, the chances are we are "cuzins."*

Martha Sue is proud of her pioneering ancestors, proud of their courageous endurance, their integrity and their unrelenting caring and kindness.

# Joe McIntosh
## *Cucumber King and More*

Some people today know where Joe McIntosh Road is, in a beautiful rural area just outside Plant City. Most people, however, don't know who Joe McIntosh was. Some have heard the stories of his feats, his kindness and his involvement with the community, and he was most of the things they have heard.

Foremost, Joe McIntosh was a farmer. Not only was he a mighty good farmer, but he was also known as a mighty good man. He ran a large, productive farming operation, employing many farm workers and shipping to markets throughout the area and to many distant points.

Once, Joe McIntosh tried to get the local markets to lower the price of their tomatoes to make them more accessible to poorer families, and he offered them a cut rate if they would do so. The markets, however, wouldn't agree to lower their prices. To accomplish his goal of making this produce more accessible, Joe advertised a "you pick" system and sold his tomatoes straight to the people for one dollar a bushel. The customers came in droves.

McIntosh would work alongside his employees, sometimes seventy-five to one hundred of them, and say, "Let's just take a little break from this heat," and then he would sit down with them. And he would cajole and joke with them. Then they all went back to work. Mr. Joe earned the respect from his farm workers.

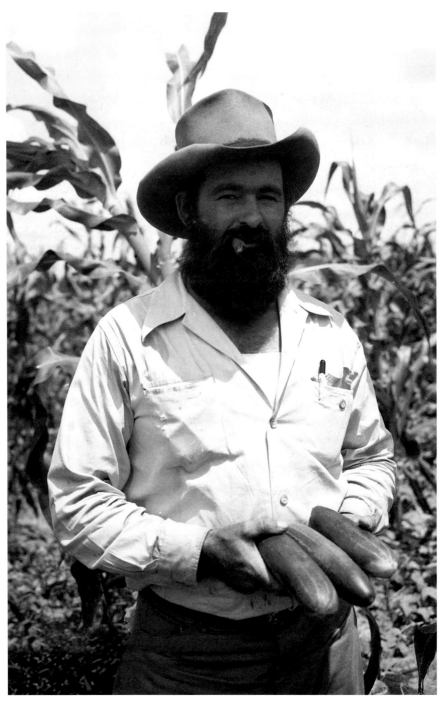

Joe McIntosh was quite successful as a farmer, growing a wide variety of vegetables, including 150 acres of corn and 350 acres of cucumbers. This 1946 photograph shows Joe McIntosh, "Cucumber King," on his farm on McIntosh Road, Plant City, Florida.

## Joe McIntosh: Cucumber King and More

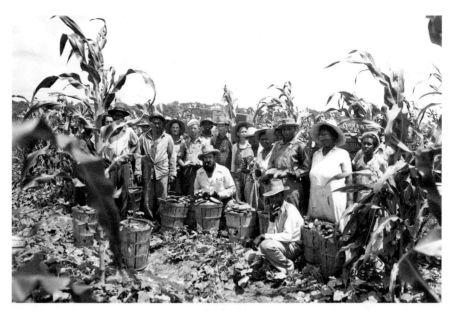

Beloved by his employees, sometimes seventy-five to one hundred of them, Joe McIntosh (center, with beard) would often work alongside them. McIntosh Farms, Plant City, Florida, 1946.

And work they did. His farm was highly productive because he believed in his workers and they produced a great deal of work. He grew watermelons, cantaloupes, eggplants, tomatoes, squash, sugar cane, beans, peas, 150 acres of corn and more. He was the first to sell his collard greens and mustard greens directly to the big Southland Frozen Foods plant in Plant City. During World War II he grew 15 acres of carrots, donated them and delivered them to Port Tampa, where they were shipped off to become C rations for the GIs.

Joe McIntosh was the king of cucumbers. He had 350 acres of cucumbers, and at harvest time he, his wife and the workers would load two to three rail cars each day. But not on Sunday. That was a day set aside for church and family. Joe McIntosh is not just a beautiful tree-lined rural road; Joe McIntosh looms much larger than that—he is the epitome of a good man, and a good farmer.

# Everyone Flocked to the Cane Grinding

**I**t had to be cold. Winter cold. After Christmas, when the cold weather rolled in, that's when the sugar cane processing began. And when the black smoke billowed into the clear sky, everyone knew a cane grinding was underway and people would come from all directions.

Joe McIntosh may have been popular for his okra and many other farm products and known as the "Cucumber King," but there was no competition when it came to the making of cane syrup. Violete (McIntosh) Massey knows about that. She was there and can tell the story of Joe's mastery. When the cold weather came and it was time to harvest the sugar cane, they would head for the fields. There they would cut the long, tall rows of sugar cane with sharp machetes, and they would strip the cane, top it, load it onto the wagons and carry it to the grinding area.

When it came time to start the process of making the cane syrup, they would start early. Sometimes they would start as early as 4:00 a.m., squeezing and grinding the cane until they filled the kettle to the 120-gallon mark. After gathering the "fat-lightered" wood (aged pieces of pine virtually oozing with turpentine), they would light the fire. It was black with the sooty but sweet-smelling smoke that would rise toward the sky—and people knew it was a cane grinding and they would come. Then, after hours of boiling, they would strain the syrup through flannel and the result would be eighteen to twenty gallons of wonderful, fresh, pure cane syrup.

## Everyone Flocked to the Cane Grinding

Much of the acres of sugar cane that Joe McIntosh raised was turned into cane syrup. This preparing and boiling of the sugar cane became known as a cane grinding, such as this one on the McIntosh Farm about 1955. Joe McIntosh is seated on the far right.

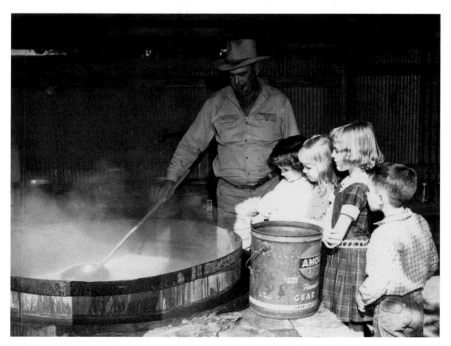

Joe McIntosh loved children. Here he demonstrates some of the techniques of making cane syrup to a group of first graders from nearby Knights School, circa 1955.

Some people would come to the grinding to participate in whatever way they could, socializing with neighbors and enjoying the wafting aroma of boiling cane syrup. Some came to observe McIntosh's techniques, then to enjoy some of the syrup themselves. But Joe always liked teaching anyone interested and frequently would entertain youngsters who would make field trips from nearby schools. When it was that time of year and the weather was right, everyone flocked to a cane grinding. Like many other agricultural events, the making of cane syrup was an exciting social event.

# The Macks of Plant City

"The Bard of Collins Street." That's what they called him. L.B. Mack, that is. Everyone knew him as "L.B." He ran the feed and seed store on South Collins Street, just south of downtown and across the street from the fledgling McGinnes Lumber Company branch.

During the Great Depression, men who were down on their luck would come to L.B. for a special favor. They could not afford a gift, not even a card, for their wife's birthday or their anniversary, and L.B. would write a poem for them. The men were proud to present such a unique and thoughtful gift. He sometimes wrote as many as two to three hundred of these in a year's time. L.B.'s son, Thomas B. "T.B." Mack, has collected twelve scrapbooks of his father's poems.

When times were tough on the farms, some storeowners extended credit and supplied the necessities for getting the next crop in, and would collect when it was harvested, if it was a good harvest. L.B. was one of these.

Lonnie Birdell Mack was born in South Carolina and moved to Florida when he was a young man, first to Wauchula, then to Vero Beach, back to Wauchula and finally settled in Plant City about 1930–31. The Macks purchased a home on West Baker in 1931, where Ruby Irene Mack, L.B.'s daughter, was still residing in 2006.

L.B. Mack worked for Kilgore Seed Company for several years. After a dispute with the company, L.B. opened up his own feed and seed store on

## *Remembering* **Plant City**

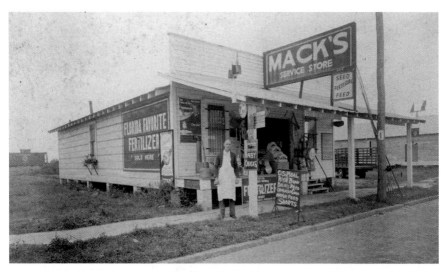

Lonnie Birdell Mack, November 1939, in front of Mack's Service Store, which he opened in the late 1930s on South Collins Street/State Road 39 just south of downtown Plant City, Florida.

South Collins Street, not far from the Kilgore Seed store. Mack's store was initially sponsored by Florida's Favorite Fertilizer, but Mack later bought it outright.

Mack's store became quite a gathering place. Many townsfolk would stop in to shop, but also to swap stories. Politics was big in America during those years, and frequently the talk turned to national, state and local politics—especially local politics. That was the seed that germinated into the infamous "Mack's Political Graveyard."

Using his poetic gift, L.B. set up his cemetery alongside his Collins Street store. In it was just about every politician who lost an election. Although the tombstones would be erected shortly after the election took place, it seems L.B. had prepared well in advance. In addition to burlap and straw, old shoes, pumpkin heads, hats and sometimes photographs, L.B. would erect a tombstone painted with a wonderful homespun story. Here are some of those verses from long ago:

*Close beside Mack's Service Store*
*Beneath all these guava bushes;*
*Are several of our personal friends,*
*Who failed in their political wishes.*

*In every game of life,*
*There was to be a winner;*

# The Macks of Plant City

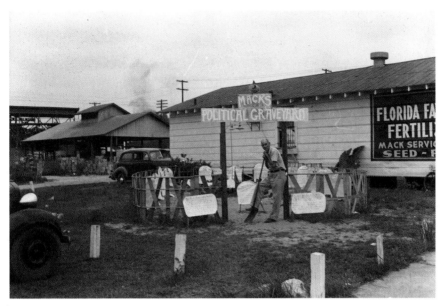

L.B. Mack's seed and feed store was a popular spot for many local men, and unsuccessful political candidates could be sure they'd have a spot in Mack's Political Graveyard, shown here in 1946.

*The sands of time move on,*
*For saint as well as sinner.*

*So as you pass and read this verse,*
*And praise the man who won;*
*Remember these are all our friends,*
*And this is all in fun.*

*CHAS. BOOTH*
*Now Charlie Booth to tell the truth,*
*We thought you were a natural;*
*But you can still sell life insurance,*
*And get more policies in your satchel.*

*That fellow Brannen was long a-planning,*
*For you he was laying low;*
*So that is why your friends all cry,*
*When we put you here below.*

# *Remembering* **Plant City**

*You thought it would be so easy,*
*And not needing to make a showing;*
*You ran around taking it lightly,*
*Your horn you should have been blowing.*

*That's the reason Charlie is here,*
*Next time again you can try;*
*But in the meantime get more friends,*
*On whose promises you can rely.*

*J. ARDEN MAYS*
*Arden Mays has quit his city job,*
*Now some several months ago;*
*He wanted a job on the Budget Board;*
*And up the political ladder go.*

*He failed to climb that ladder,*
*Now look where he is today;*
*Lost, rejected, could not win,*
*The voters have had their say.*

*It peeves us to do this Arden,*
*But you know it must be done;*
*Another day you can try again,*
*When Carey don't care to run.*

The *Tampa Tribune* paid tribute to L.B. Mack in an article in the September 10, 2003 edition, with a photo of Mack's political graveyard. Politics was a tough, serious, yet fun-filled activity in the days of that era.

Young Thomas B. Mack played football for the Plant City High School Planters. He worked at his father's store, moving two-hundred-pound bags of feed and seed and gaining muscle. He made all-state when he played on the 1932 team, which destroyed virtually every opponent of the so-called "Big Ten" conference. Most of all, the Planters wanted to beat Tampa's Plant High, and they did. It was more of a free-for-all than a football game, almost a brawl, but the Planters emerged victorious, and T.B. blocked three punts, all of which resulted in touchdowns.

T.B. Mack, recently deceased, was known as "Mr. Citrifacts," was professor emeritus at Florida Southern College and directed the Citrus Museum.

## The Macks of Plant City

He recalled that Plant City was the place on Saturday nights in those years. People would come to town from everywhere. If they drove, they would have to park far from the center of town and walk back into the downtown district. There were no parking lots then. Others would walk into town from home. But they all went to town on Saturday nights. The sidewalks bulged with people, as did the restaurants, soda shops and theatres. Retail establishments would stay open until 11:00 p.m. or midnight if people were still shopping—and frequently they were.

During those years, kids would pick strawberries for pocket money, and on Saturdays they would go to town. They would feast on five-cent ice cream cones, cram into small photograph booths to get their pictures taken for ten cents for a strip of four photos and then head to the Capitol or State Theatres for a ten-cent double-header.

Young T.B. left Plant City to attend the University of Florida and later served in the U.S. Army. He got into the citrus industry and gravitated to Florida Southern College, where he stayed for about fifty-four years. He developed Florida Southern's horticulture and citrus program and taught in the program for many years. He also established the magnificent Citrus Archives Center on the campus of Florida Southern and oversaw that until well after he "retired." The Mack family has left its mark on Plant City's fascinating history.

# Mr. E.L. Bing
## *Educator and Leader*

The following is a first-person narrative by Photo Archives Advisory Council Member Bill Thomas, as told to the editor.

*The newly constructed Marshall High School, named for Supreme Court Chief Justice John Marshall and previously known as Midway Academy (and for a short time as Plant City Negro High School), opened its doors in 1958. It was segregated and blacks from Bealsville, Hopewell, Knights Station and the general Plant City area attended the school.*

*Attending Marshall High School was both an educational and cultural experience. My introduction to Mr. E.L. Bing began when I entered Marshall High. Mr. Bing was the principal at Marshall High School and thus was responsible for the education of all who attended. As a young seventh-grader, I did not realize, nor could I have known, the effect that this experience would have on my life as well as those of my fellow schoolmates. I use the term schoolmates because, although you were a part of a particular graduating class, you attended Marshall High with students who were up to six years older and/or younger, thus developing broad relationships that would have a lifelong effect on your future.*

# Mr. E.L. Bing: Educator and Leader

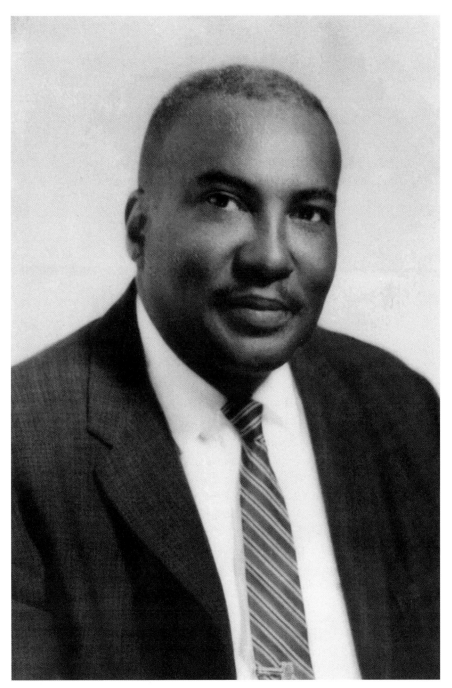

Mr. E.L. (Elijah Lutrell) Bing was an educator, an outstanding administrator and a beloved leader in Plant City and Hillsborough County schools. He was the principal of Marshall High School when this photo was taken in 1967; E.L. Bing Elementary in Tampa, Florida, was named after him in 1991.

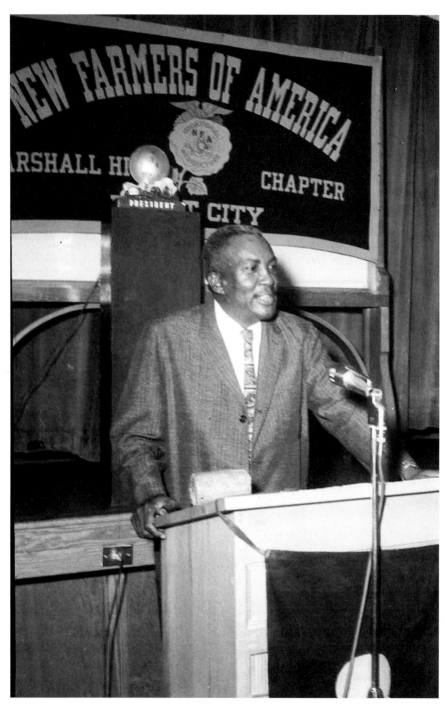

E.L. Bing was known as a motivating speaker, as shown here at Marshall High School in 1961. He served as principal from 1954 until 1967, when he was named director of federal projects for the school district.

## Mr. E.L. Bing: Educator and Leader

Mr. Bing was officially principal administrator of Marshall High but, because education was viewed as the vehicle to prosperity, Mr. Bing, "educator and leader," was more important than I could have imagined. As I look back now, I truly realize the difficulties Mr. Bing faced. His leadership ability in bringing together a faculty of true professionals—teachers, librarians, administrative staff, culinary staff, secretaries, custodians, etc.—was magnificent. It was a feat that I did not come to appreciate until I was an adult responsible for my own life and well-being.

I can only imagine the difficulties Mr. Bing faced in the Jim Crow segregated South, acquiring the essentials such as books, supplies, equipment and the funding necessary to provide a positive and fruitful educational experience for his students—especially when you consider that the books and most equipment available were used hand downs from Plant City High School and Tomlin Junior High.

In 1967 I graduated Marshall High School and attended Bethune-Cookman College in Daytona Beach. I entered the U.S. Army in 1969, and received an honorable discharge after a successful twenty-four-year career, which included tours of duty in Vietnam, Central and South America, Europe and assignments across the United States. It was only after I entered the U.S. Army that I realized the education I had received at Marshall was second to none. I remember well that the curriculum included mathematics (algebra, geometry, trigonometry), science (general science, biology, chemistry), social studies, history (U.S. and world), economics, world literature, foreign languages and typing. And there was physical education (and an exposure to ballroom and square dancing and bowling), home economics, arts and crafts, mechanical/industrial shop and all other extracurricular activities needed to produce a well-rounded educational environment.

At Marshall students were grouped according to a color code—green, blue or red. Although I am not sure what criteria Mr. Bing used to determine which students would be in which group, I believe it was based on end-of-the-year academic test scores. Considered to be a good student, I found myself in the green group, which by today's definition would be college preparatory. This in itself is a testimony that Mr. Bing's educational philosophy was well before its time.

I never fully applied myself or maximized my academic potential while at Marshall; nonetheless, the simple exposure to Mr. Bing's educational system prepared me for experiences and achievements beyond the goals I had set at graduation. My typing skills continue to benefit me today, particularly in my ability to navigate the computer keyboard

with above average speed and accuracy. While in the army, I completed my criminology/psychology degree and competed for and was accepted in the two-year forensic science training program, specializing in latent print examination. I was one of only fourteen in the Department of Defense. Not bad for a black kid from Marshall High—especially when you consider that there were nearly two million soldiers, airmen, Marines and sailors in the armed forces. Over the years I have asked myself many times what made it possible, and the answer continues to be Mr. Bing and Marshall High School.

I credit much of my own success over the years to Mr. E.L. Bing's educational philosophy as I experienced it in those years at Marshall High School. And the reason for Mr. Bing's overall success as a principal and educator was his ability to select the best and the most dedicated teachers. Mr. Bing's ability to recruit teachers who demanded your best, and who gave their best, was responsible for creating the most well rounded educational experience a student of any color could have received.

Here are some of the reasons for my conclusions. All students were required to attend six classes each six-week period. Some students could select up to three electives; however, the green group (college preparatory) continually had five of the six classes designated as part of a curriculum established by Mr. Bing. During our junior year we had no electives—we were told that economics would be our elective, just as we had elected to take typing, Spanish and other non-traditional classes. (In conversations with graduates of other high schools I discovered not only that they were not required to take typing, but also that they could not even take it if they desired to—there were no typewriters available.)

One day during my junior year, while in economics class, my classmates and I felt the teacher unfairly punished a student. We took it upon ourselves to right a grave wrong that we felt had been perpetrated against one of our classmates. We boycotted the class, even the students whose personalities were docile. Mr. Bing was summoned back to Marshall, interrupting a meeting he was attending. Although he was not happy with our action, Mr. Bing applauded our togetherness and our willingness to stand up for what we thought was right.

There were many great teachers and other faculty members who played a role in the Marshall experience, but it was Mr. Bing's exceptional education expectations, his leadership skills, his ability to recruit and motivate the faculty he needed to accomplish his goals and his steadfastness as leader in not allowing skin color to be an

## Mr. E.L. Bing: Educator and Leader

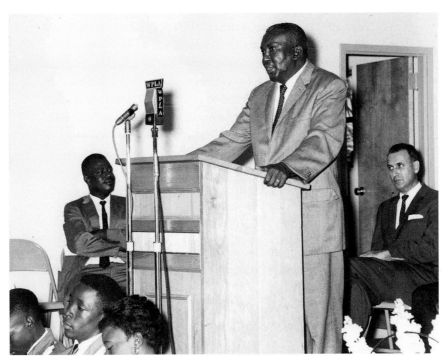

E.L. Bing was one of the driving forces that led to the construction of the Haines Street (now Dr. Martin Luther King Jr.) Recreation Center in 1961. Plant City Mayor John Glaros is seated far right.

*excuse for lack of achievement that made this outstanding educational environment possible.*

*Mr. Bing's tenure as principal at Marshall High School produced a multitude of professionals: doctors, lawyers, nurses, teachers, business owners, pilots, outstanding military service men and women and many white- and blue-collar professionals. All of these graduates have made positive contributions not only to their communities, but also to their country and the world.*

*In 1965, Mr. Bing used education to break color barriers. He was instrumental in getting a student employed as a stock clerk at Winn-Dixie supermarket and a former student hired as a clerk at the U.S. Post Office in Plant City. By today's standards that sounds small, but in 1965, that was monumental.*

*Mr. Bing was also instrumental in getting students from Marshall High involved in an experimental criminal justice program where students sat on juvenile juries in the Hillsborough County Court system to hear cases involving their peers and to make recommendations to the judges about appropriate punishments.*

## *Remembering* **Plant City**

*A few weeks ago, the Haines Street Recreation Center, as it was first known (now known as the Dr. Martin Luther King Jr. Recreation Center), celebrated forty-six years of service to the children of Plant City. This facility was made possible through Mr. Bing's leadership in community affairs. Mr. Bing's tenure as principal at Marshall High ended in 1967, the year of my graduation, when he was appointed director of federal projects for the county school district. His legacy of providing the best education possible will live for generations to come.*

# Lew James Prosser
## Plant City Agriculturist and Businessman

For over sixty years the name of Lew J. Prosser has been closely identified with the citrus industry in Plant City and beyond. Although many people may not realize all that he did in his years in the industry, Prosser had an impact that continues to this day. His knowledge of citrus and produce resulted in a number of revolutionary changes in processing and marketing crops that advanced the industry and aided the economy of the entire area.

Lew James Prosser Sr. was a Pennsylvania bituminous coal operator who moved to Miami in 1906 for its greater financial potential. Lew James Prosser Jr. attended elementary and high school in Miami and later moved to the Plant City area.

In about 1921, while still a young man, Lew J. Prosser began in the citrus industry. He became a partner with R.W. Burch, a pioneer Plant City citrus and produce shipper, in 1924, and sole owner in 1928. He expanded the citrus operations to five citrus-packing plants in 1930 and became the third largest independent shipper of citrus fruit in Florida. In the same year, he became Florida's largest watermelon dealer and expanded into Georgia and South Carolina. Prosser went on to become Plant City's largest citrus fruit grower and one of the area's leading dealers in strawberries and produce.

As a citri-culturist, Prosser traveled extensively throughout many of the citrus-producing areas of the world, studying methods, history and practices. He was an inventor and an aggressive innovator.

## *Remembering* **Plant City**

Lew James Prosser (1968) was a successful businessman who owned and operated citrus groves, packing plants, automobile dealerships, watermelon dealerships and more, and was renowned for his inventions and innovations.

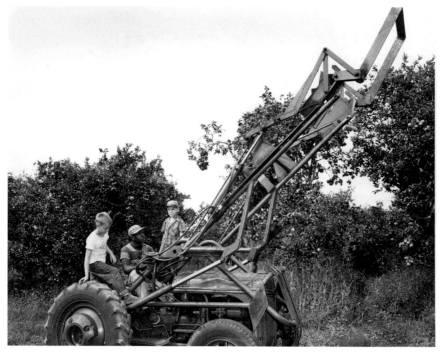

Prosser Groves' employees demonstrate one of Lew Prosser's new citrus harvesting rigs in 1951.

# Lew James Prosser: Plant City Agriculturist and Businessman

His list of accomplishments is long, and includes the following. He formed the Florida Mixed Car Company, specializing in marketing mixed car lot shipments of citrus and produce, heretofore not done. He introduced to the Plant City area the extensive growing of bell peppers to follow the strawberry crop, thus prolonging the strawberry growers' season and improving the economy of the east Hillsborough growers and the community. He established the first packinghouse devoted to the creation of a uniform grade and pack for bell peppers. He introduced and developed the patent for the tri-sodium phosphate bath, thus eliminating the necessity for wrapping oranges and grapefruit separately in specially treated paper. He developed a new system for the dyeing of oranges. He established the Plant City Production Credit Company, administered by his company and operating under the U.S. Farm Credit Administration, providing a much-needed credit system for local farmers. And in 1944, Prosser organized Plant City's first citrus canning plant, which included a cattle feed division and a citrus molasses plant division.

In 1934 Prosser achieved the greatest benefit to the strawberry growing community by underwriting a case before the Interstate Commerce Commission to establish car lot express shipments of strawberries. Heretofore, they had been shipped by pony reefer containers, requiring a great deal of individual packing, icing and loading—plus the railroads were not expeditious in returning the expensive reefers for the next shipments, causing additional expenses and resulting in undue delay. The car lot express shipment approved by the ICC was a huge boon to the strawberry growers and shippers.

Prosser later wrote the *Early History of the Produce Industry in Plant City*, in which he attributes the development of Plant City's produce industry to the access to railroad transportation. In 1920 Plant City was recognized as the largest inland shipping point in Florida.

In addition to his other business interests, Lew Prosser got into the automobile business and for a number of years operated the Hudson Automobile Agency, serving almost all of Florida and two-thirds of Georgia. He was recognized at one time as the largest automobile distributorship in the United States. He married Vaviel Madeline Wilbur, of Plant City, in 1928; they have one daughter, Sally Madeline Prosser Verner, who is married to Dr. John Verner, retired partner of the Watson Clinic of Lakeland.

# R.E. "Roy" Parke and Parkesdale Farms

Robert E. "Roy" Parke Sr. emigrated from Northern Ireland to southwestern Pennsylvania in 1924 with his wife and four sons and became a successful vegetable farmer. Roy Parke Jr. was raised there on the farm, attended public schools and spent most of his time learning the farming business.

When World War II broke out, young Roy answered the call, serving in the U.S. Army Airborne and Infantry. He served in the European theatre, seeing action in France and Germany in 1944–45. When Roy Jr. returned home he rejoined his father and expanded their farm operations.

In 1956, the Parkes—Roy Sr. and Roy Jr., with his wife, Helen—and their families moved to the Plant City, Florida area and established a farming operation in Dover: "Parkesdale Farms, R.E. Parke & Son." Roy Jr., Helen and their children expanded the farms and the company into hundreds of acres of the best strawberries, tomatoes, peppers, cucumbers, sweet onions and cantaloupes found anywhere. Parkesdale Farms also have their own nurseries, including four greenhouses, where they grow over a million vegetable and flowering plants annually.

Concentrating on growing strawberries, the Parkes became one of the largest strawberry producers in the state. They also set up a roadside strawberry and produce market in 1969 that has become a favorite for tourists who want to enjoy the succulent berries and Parkesdale Farms'

# R.E. "Roy" Parke and Parkesdale Farms

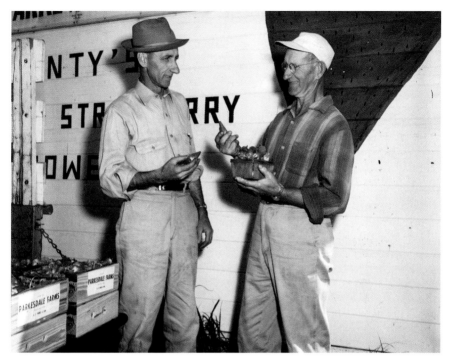

R.E. "Roy" Parke Jr. and his father, Robert E. "Roy" Parke Sr., in 1962. Roy Parke followed his father in the agriculture business and became the most widely known strawberry grower in the county.

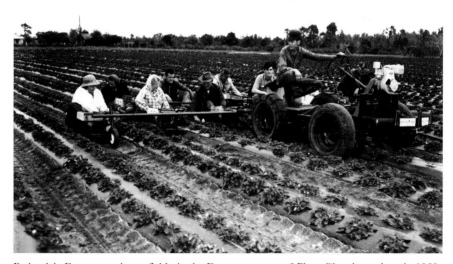

Parkesdale Farms strawberry fields, in the Dover area west of Plant City, shown here in 1962, were highly productive and produced outstanding quality and quantities of luscious berries.

outstanding World Famous Strawberry Shortcake. The family continues to operate the market, which is now the largest fresh strawberry, citrus and produce market in Florida.

For the 1975–76 strawberry season, the planting for which began in September, Parke set out 860,000 plants on the forty-five acres dedicated to strawberries. The Parkesdale Farms yield is about 20,000 pints to the acre. What is not consumed locally, at the roadside market or at the Strawberry Festival, is shipped to domestic and international markets. The crops, which begin coming in during the last part of November and continue through April, are still hand-picked, sorted, cleaned, packed and shipped to market; 90 percent of the crop is shipped by refrigerated trucks and the balance by rail or air. It was Roy Parke and Parkesdale Farms that first successfully air-shipped strawberries to the European markets in 1963.

Roy Parke Jr. was the first inductee into the Strawberry Hall of Fame and has provided considerable leadership for the Florida Strawberry Festival, serving on the board of directors for many years.

# The Southland Frozen Foods Corporation and D. Herman Kennedy

A young man walked into Ben Knott's Hardware in 1943 and announced that he was Herman Kennedy from Alabama and was setting up a bean plant in Plant City. He said he needed a little credit and a source of supplies and equipment. He got it. D. Herman Kennedy was employed by Southland Frozen Foods Corporation to establish the company's vegetable operations in Florida. Southland's Plant City plant began in a wooden building owned by Seaboard Railroad on Gilchrist Street, adjacent to the tracks, and rose to become one of the nation's leading vegetable processors.

Southland began operations in the fledgling Plant City plant in October 1943, in the midst of World War II, and employed twenty women and five men. The first woman employee was Alma Barry, who remained with Kennedy for many years. In 1943 the new plant processed approximately twelve thousand pounds daily and specialized in beans and strawberries. Kennedy had a fondness for strawberries, but green beans were to remain the foremost product throughout the years.

In the early years, Kennedy was "everything" at Southland, said Mrs. Barry. As production increased, new employees were added to the staff: Dr. Gray Singleton, Doyle Tatum, Bumpsy Lockhart, Lucian Robinson, Ben Dailey and many more.

To provide storage space for its frozen foods, the company built Plant City Cold Storage in 1946, with Mr. R.E. Roberts as one of the first refrigeration

## Remembering **Plant City**

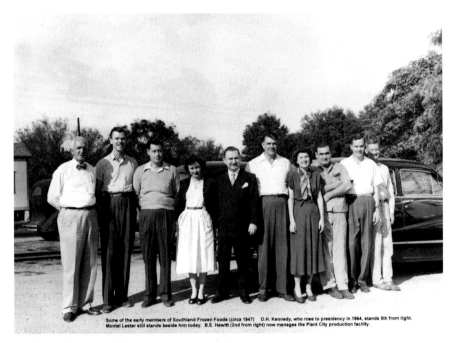

Some of the early members of Southland Frozen Foods (circa 1947). D.H. Kennedy, who rose to presidency in 1964, stands 5th from right. Montel Lester still stands beside him today. B.E. Hewitt (2nd from right) now manages the Plant City production facility.

D. Herman Kennedy (fifth from right) began with the Southland Frozen Food Corporation in upper New York State and opened its Plant City operations in 1943. Here are some of Southland's leading employees in 1947.

engineers. Kennedy then toured the country visiting processing plants, and in 1949 Southland built a modern processing plant off Laura Street near the Seaboard Railroad tracks, not far from the downtown business district. The plant was constructed over a well for a continuous supply of water, a necessity in the vegetable processing plant.

By the time Southland celebrated its tenth anniversary, it had grown to include many new items in addition to green beans and strawberries, and set up operations in Dover, two plants in Tennessee and one in New York. Kennedy also worked closely with Dr. A. Nelson Brooks, a plant pathologist with the Florida Agricultural Experiment Station in Springhead, in developing the No. 90 Strawberry, which became an important variety for strawberry growers for years. Southland used the No. 90 exclusively for processing. Southland became a major buyer of east Hillsborough's vegetables and strawberries.

The *Tampa Daily Times* reported the following on August 15, 1953:

> *In this plant of Southland Frozen Foods, Inc., at Plant City more than 1,200 carloads of vegetables and produce fresh from fields of east Hillsborough County (principally) are processed, packaged and frozen*

# The Southland Frozen Foods Corporation and D. Herman Kennedy

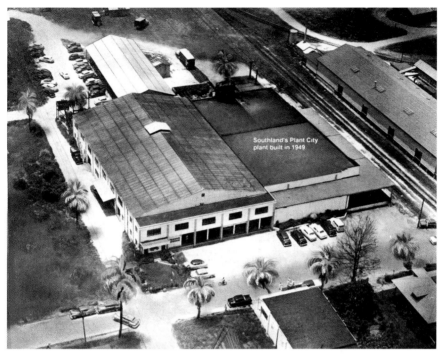

With continuing growth, Southland built a new cold storage facility in 1946 and followed with this large modernized processing plant just southeast from the center of town along the Seaboard railroad tracks in 1949.

*each year to end up finally on America's dining tables. Southland's Plant City unit produces more frozen foods than any other plant of its kind in the Nation.*

These Southern vegetables include baby okra, collards, mustard, turnip greens, field peas and baby crook-neck squash.

In December 1954 a young employee set fire to the plant and caused over $100,000 in damage. Despite this setback, Southland rebuilt and continued to grow. Kennedy was named corporate executive vice-president in 1958, with responsibilities over all of Southland's operations and various plants. Kennedy still found time to research and plan, and in 1960 designed and built the cluster cutter machine for the Plant City bean operation and also designed an okra cutter.

Southland now operated around the clock and produced 11 million pounds of beans annually—200,000 to 250,000 pounds daily. Then, in 1962, Phil Rizzuto, corporate president and founder of Southland Frozen Food Corporation in 1943, died of cancer. He named D. Herman Kennedy as his choice to succeed him as president. Even with corporate offices

## Remembering **Plant City**

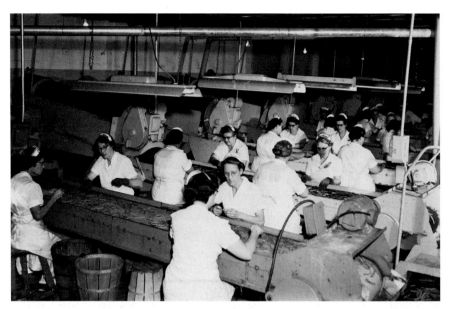

By 1956 Southland was a major buyer of east Hillsborough's vegetables. The company was one of the top frozen food companies in the United States and a major employer in the Plant City community.

in New York, Herm Kennedy continued to live in Plant City. He and Southland were involved in the community, participating in parades and civic organizations, sponsoring little league teams and more.

Another major step came in 1968, when Southland added a huge ten-million-pound cold storage facility adjacent to its Plant City production operations. It was a one-million-cubic-foot building of the latest design. The Plant City facility became one of the most efficient in the nation and produced all of Southland's Southern vegetables—more than thirty million pounds of frozen vegetables per year. Southland was the pride of Plant City for years to come.

The story of Southland Frozen Foods cannot be told separately from the story of D. Herman Kennedy, who served Southland in various capacities for forty-three years. Kennedy began working with Philip Rizzuto, the founder of Southland, at the Ontario Center, New York operation in the summer of 1943. Later that year, Rizzuto asked Kennedy to set up a production and processing plant in Plant City, which he did.

Not only was Herman Kennedy in charge of production in both the New York and Florida operations, but Charles Rizzuto, Southland president, also said in 1983 that "from then on until the beginning of 1970, Herm almost single handedly designed, built, and ran the production department of Southland Frozen Foods."

# The Southland Frozen Foods Corporation and D. Herman Kennedy

D. Herman "Herm" Kennedy was a driving force in the Southland operation. It was said that he "almost single-handedly designed, built and ran the production departments of Southland Frozen Foods." This photo was taken in January 1955.

Kennedy, Rizzuto continued, "was resourceful and dependable, and no production challenge was too tough for him; Herm had the ability to get things done that nobody at the time thought was possible, and more than once he was called upon to do the impossible." Within twenty-five years, Southland had become one of the largest frozen vegetable processors in the nation. (Oh yes, and strawberries!)

Starting with Southland as a maintenance foreman, Kennedy quickly rose to become production manager, vice-president, executive vice-president and, after Philip Rizzuto died in 1962, he assumed the role of president. In 1970 Herman Kennedy became chairman of the board of Southland Frozen Foods, Inc. The corporate headquarters were in New York, first in New York City, then relocated to Great Neck, Long Island. Kennedy rejected the idea of moving to New York and continued to live with his family in Plant City. The family summered on Lake Ontario, when he would work from the Barker, New York plant.

That was the way Herm Kennedy was. Friends remember him as a big man with a big smile who loved his family and worked hard to serve his community. And he could fish, too.

Herm Kennedy also knew the farmers and worked with them. He worked with Joe McIntosh to persuade him to grow vegetables for Southland, and

at times he bought virtually all of the 180 acres of vegetables McIntosh produced. He maintained a staff of specialists, including soil chemists and technicians, to work with the farmers to help increase the quality and quantity of their produce and to provide assistance in seed selection, crop rotation, harvesting and marketing.

Herm Kennedy sponsored little league teams, Future Farmers of America programs, civic club programs and participated in civic celebrations and parades. He said, "Southland has become and will remain an integral part, and a loyal member of the Hillsborough community." And he was a man of his word.

Kennedy passed away in 1986. Not long after, Southland was bought out by Stilwell Frozen Foods and the Plant City operation was closed. Over the years, Kennedy worked with people like Alma Barry, Montel Lester, B.C. Hewitt, John Phillips, James Mortimer, Gerald Herring, Leo Albright, Doyle Tatum and many more whose families will continue to remember Southland and the spirit of Southland—D. Herman Kennedy.

# Nothing Like Hometown Banking

As churches provide the spiritual foundation for the growth of a community, banking provides the capital. And no financial institution does it like the "hometown bank."

The exact records of the first bank in Plant City seem to be lost. There were banking-type operations in the late 1800s, but none lasted long. In 1891 Moreau E. Moody came to Plant City and opened a drugstore; by 1900 merchants were depositing money in his large steel safe for security. By the summer of 1902, Moody and several others, including its first president Colonel James L. Young, organized the Hillsboro State Bank, and in 1914 moved the bank into the newly erected structure at the intersection of Collins Street and Reynolds Street—the center of town. Other banks were opened and closed, but the Hillsboro State Bank was the only one of Plant City's early banks to weather the financial storms and remain solvent. It came through the panic of 1917 and the epidemic of bank failures in 1929.

A druggist by trade, Wesley Benjamin "W.B." Herring had an interest in finance and helped open several banks: the Bank of Plant City in 1907 (on Collins Street next to the Wells Building), the First National Bank of Plant City in 1912 (on the corner of Haines Street and South Collins) and Farmers and Merchants Bank in 1920 (on the corner of North Collins and North Drane Street), later reorganized as Citizens Bank about 1930. By the

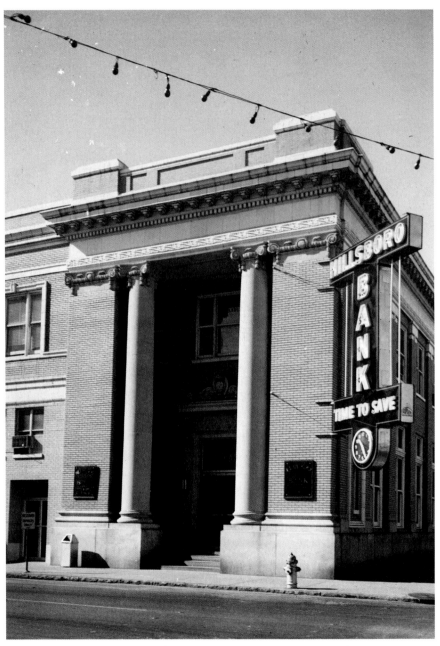

Hillsboro State Bank was founded in 1902 and this brick edifice at the center of town (the southwest corner of Collins and Reynolds Streets) was constructed in 1914. It became Hillsboro Bank in 1957. After moving to a new location, this building was vacated. It is now a law firm and the building is listed on the National Register of Historic Places.

## Nothing Like Hometown Banking

Moreau Estes "M.E." Moody was Hillsboro State Bank's first cashier and became president in 1928. The trophy fish (perhaps a tarpon) remained in the bank's lobby for years.

early 1930s, all but the Hillsboro State Bank had disappeared. From the early 1930s until 1954, Plant City was a one-bank town. The Hillsboro State Bank was the hometown bank.

Another local bank, the First National Bank in Plant City, was opened in 1956 on Haines Street, just south of the downtown area, where more land was available. Unlike the stodgy Hillsboro State Bank Building, with its traditional columns, the First National Bank in Plant City was a modern structure and featured a new concept: drive-through banking windows. It was immediately popular. To compete with this, the Hillsboro State Bank bought the former home of Colonel James L. Young and Dr. Calvin Young (who had served as president of the bank until he died in 1956) on the corner of Evers Street and Reynolds Street, one block from the main bank building, and sold the home, which was moved to a new location.

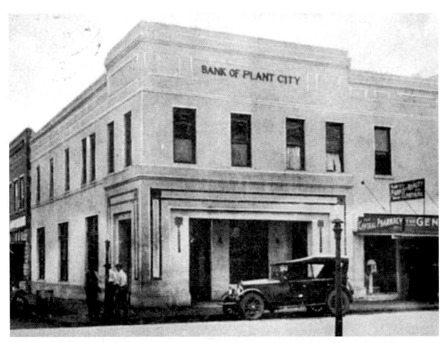

The Bank of Plant City was organized and opened in 1907, and moved to this corner location in the center of town, directly across the street from the Hillsboro State Bank, about 1919. It remained there until it closed in 1929.

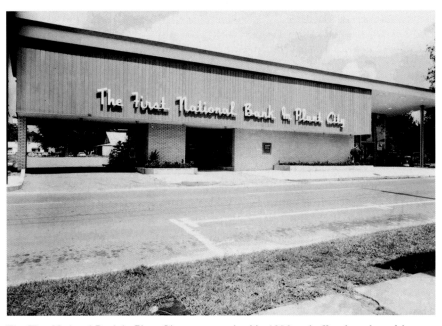

The First National Bank in Plant City was organized in 1956 and offered modern drive-through banking—the only financial institution to offer such service at that time.

# Nothing Like Hometown Banking

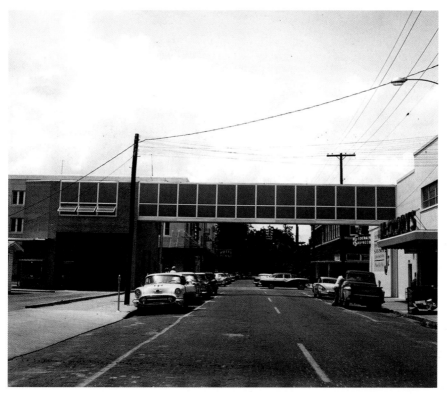

Florida state law did not permit branch banking in the 1950s. In order to compete with the new drive-through banking, Hillsboro Bank constructed a freestanding drive-through facility and then connected it to the main bank building with a block-long elevated walkway—thus making it contiguous and a part of the main office. This picture was taken in 1958.

Because Florida state law at the time did not permit branch banking, and Hillsboro Bank (they dropped the "State" from its name about this time) did not have ample space for expansion, the officers of the bank decided on another approach. They constructed a building on the corner where the Young house had sat and connected it by way of an elevated walkway across Evers Street and across the one-story McCrory's Building to the back of the Hillsboro Bank Building. Thus, it was now contiguous, and not a branch. This became their drive-through facility in 1958.

Hillsboro Bank later bought the old Hotel Plant property, razed the hotel and in 1966 constructed a new large three-story building on the northwest corner of Reynolds Street and Evers Street, complete with a new drive-through facility across Reynolds Street on the same lot as the former drive-through. Hillsboro State Bank became Hillsboro Bank, then Sun Bank and later became part of the SunTrust banking family, and is

The First Federal Savings and Loan Association (known today as Sunshine State Federal) was organized in 1954. It opened this new facility about 1961, one block from the center of Plant City.

no longer a "hometown bank." The First National Bank in Plant City later joined First Financial Corporation, a holding company, in 1970 and is no longer doing business.

The brick building constructed by the Hillsboro State Bank in 1914 housed the bank for many years, and its retail space housed Barker's Department Store until about 1930, when Barker's moved across the street and McCrory's 5-10-25 Store moved in. In the northwest corner of the building was a barbershop, and offices were on the massive second floor. When McCrory's moved out, the retail space became the Family Shoe Store, and in 2005 Plant City Photo Archives set up its offices and Exhibit Gallery. The law firm of Trinkle, Redman, Swanson, and Coton took over the banking area. The building is listed on the National Register of Historic Sites.

# Nothing Like Hometown Banking

During the Great Depression years, many bank reforms were put into place. Some of this legislation specifically targeted the desperate housing problem. These included the Federal Home Loan Bank Act (1932), the Home Owners Loan Act (1933) and the National Housing Act (1934), which established the Federal Savings and Loan Insurance Corporation (FSLIC). These programs made long-term mortgages possible and transferred the risk from the mortgage lender to the government. The proliferation of savings and loan associations followed.

In 1954, another financial institution, First Federal Savings and Loan Association, was organized in Plant City to address the housing shortage and to encourage home building. The original promoter and organizer was James S. Moody, who was serving in the state legislature and was the great-nephew of M.E. Moody. James S. Moody was an attorney in partnership with John R. Trinkle. Joining Moody were Ed Cunningham (of Badcock Furniture); C.G. Green (Green's Furniture); Edgar Hull (Edgar Hull Jewelry); J.W. Jourdan Jr. (Rogers and Middlebrook Grocery); J. Arden Mays (cattle, citrus, real estate); Willard D. McGinnes (McGinnes Lumber); Lew Prosser (citrus, packing, agri-business); John R. Trinkle (attorney and law partner of James Moody); and Don E. Walden (Strickland Hardware, Arctic Ice and Walden Chevrolet). McGinnes, who served as president or chairman of the board for over thirty years, continued to serve on the board into his nineties.

The fledgling financial operation found office space in the Wright Arcade Building on West Reynolds Street and set up business in 1954. Looking for more space, in 1957 the successful business moved across the street to an office in the McCrory's Five & Dime Store Building at the corner of Reynolds and Evers Streets.

Still needing more space, First Federal directors bought the former home of S.E. Mays at the northwest corner of Baker and Collins Streets, razed it and erected its new facility in 1960. The association also bought and razed several other properties, taking control of the block bounded by Baker, Collins, Herring and Evers Streets.

In addition to its branches, today's Savings and Loan Association's central banking facility is much enlarged and updated. Although the name was changed in 1975 to Sunshine State Federal Savings and Loan Association, it is the same institution begun by James Moody and the other community leaders in 1954. But for the recent addition of the new locally owned Hillsboro Bank, Sunshine State Federal Savings and Loan Association remains the "hometown bank," and is certainly the oldest locally owned financial institution in Plant City.

One of the special attributes of hometown banks is their involvement with the community. Sunshine State Federal is deeply involved in the Greater Plant City Chamber of Commerce, is a major supporter of the new John R. Trinkle Center at the Plant City campus of Hillsborough Community College, is a major sponsor of the Plant City Photo Archives and the Bruton Memorial Library and is a sponsor in support of almost all local nonprofit organizations and programs.

# The Young and Moody Building
## A Multifaceted Showpiece

Plant City has many outstanding historic buildings, and many of them, such as the Young and Moody Building, have interesting histories of their own. Palestine Hamilton Collins Wright, ex-wife of Dr. Olin Wright, sold the western half of the property and land on the north side of Reynolds Street between Collins Street and Evers Street to Colonel James L. Young, Moreau E. Moody and Dr. Calvin T. Young, son of the colonel, in 1923. There they constructed the Young and Moody Building.

Who were these men? Moreau Estes (M.E.) Moody and Colonel James Laurens Young came to Plant City at about the same time. M.E. Moody came from eastern Tennessee and established a pharmacy in Mango in 1885 and relocated to Plant City in 1891. Colonel Young, from South Carolina, was a veteran of the Confederate army and a graduate of the law department of the University of Mississippi. He came to Florida in 1885 and Plant City in 1886, where for thirteen years he was the legal representative for the Florida Central and Pacific Railroad.

Colonel Young and M.E. Moody, with a number of other businessmen, organized the first bank in Plant City, Hillsboro State Bank, in 1902. Colonel Young served as president of the new bank until his death in 1928. M.E. Moody then became president and served until his death in 1945, and was followed in the presidency by his nephew, Thomas Edwin Moody ("Mr. Edwin"), until his death in 1948. Colonel Young's son, Dr. Calvin T. Young,

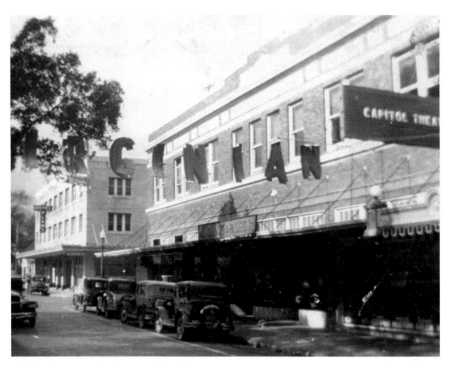

Colonel James L. Young, his son Dr. Calvin T. Young and Moreau E. Moody partnered to build one of the most architecturally detailed buildings in 1923. The Young and Moody Building was completed in 1924. The photo shows some of the earlier tenants: the Capitol Theatre and the Great Atlantic and Pacific Tea Company, circa 1929. (*The Virginian* starred Gary Cooper.)

became president of the bank in 1948 and continued in that capacity until his death in 1955.

But it was in 1923 that Colonel Young, M.E. Moody and Dr. Calvin Young partnered to construct one of the largest and most architecturally detailed buildings of the time, the Young and Moody Building, located at 110–118 West Reynolds Street. The construction began in 1923 and was completed in 1924. This two-story brick structure features decorative detailing on the second story consisting of rectangular tile motifs and terra cotta lion masks and swags in the frieze of the entablature. It is magnificent. To the west was the block of historic homes, to the south the elegant Hotel Colonial and the stately Hillsboro State Bank, the wooden Magnolia Pharmacy building was adjacent to the east and next to that was the brick Trask Building, which housed the post office. Behind the building to the north were the central park (City Hall Park), the Masonic Lodge and city hall.

The Capitol Theatre opened in the Young and Moody Building in March of 1924 to throngs of moviegoers and onlookers. The movie house occupied most of the first floor, and its screen took up much of the second.

# The Young and Moody Building: A Multifaceted Showpiece

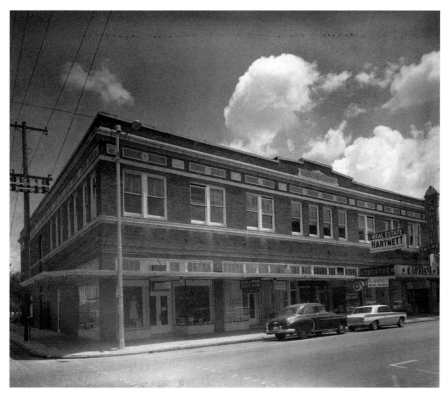

Over the years the Young and Moody Building underwent a number of face-lifts and changes in tenancy, but the Capitol Theatre remained until the 1960s. Here is the building in 1962.

Storefronts and offices occupied the remainder. The Atlantic & Pacific Tea Company was one of the early tenants, and W.E. Lee Company leased most of the office space on the second floor.

In addition to the excitement of the theatre, the second story of the Young and Moody Building also has had excitement over the years. It seems that at one time it housed a young men's social club, and later the Elysian Club, which reportedly drew complaints from neighbors at the Hotel Colonial across the street. Even the American Legion Auxiliary partied in the upstairs clubrooms.

In addition to the businesses mentioned earlier, the first floor saw a great variety of enterprises, including Mrs. Cameron's Vanity Fair; several restaurants, including the Savannah and Harry's Place; real estate and law offices; a florist; a jeweler; Plant City Travel; a beauty salon; and Tatum & Johnson's Department Store, among others. From 1929 until the new church building was completed in 1931, the Holy Name Mission, now St. Clement's Catholic Church, held services in the Capitol Theatre.

# *Remembering* **Plant City**

The historic Young and Moody Building has undergone several face-lifts and remodels in the past, but none compares with the complete renovation of the building in 2002. It reopened in January 2003 with a grand opening that drew a large crowd of pleased spectators to see the historic structure as a showpiece once again.

# The Wright Arcade
*A Unique Story*

The Wright Arcade Building sits in downtown Plant City along West Reynolds Street, near the center of town. It has participated in and has witnessed many years of Plant City's history. With its arched façade and faux stained glass, it is an interesting and unique structure.

Dr. Olin Seymour Wright began his medical practice in Plant City in 1887. He married the beautiful socialite Palestine Hamilton Collins the following year. They were active in civic affairs and in real estate. Dr. Wright served on the county school board and several terms as mayor. They owned property in Hillsborough, Manatee and Pinellas Counties, including Plant City's Magnolia Pharmacy and the White Brick Drug Store.

Shortly after the turn of the century, Eben Trask, who had again been appointed postmaster, constructed a new building on the northwest corner of Collins Street and Reynolds Street and moved his business into it from 104 West Reynolds Street. The Magnolia Pharmacy then moved from Collins Street into the wooden structure at 104 West Reynolds. To the west was the city bandstand and, in 1910, the Hotel Colonial occupied the south side of Reynolds Street.

Eben Trask died in 1921 and in 1922 the post office was moved to the new Lee Building at 110 East Reynolds Street. Henry Shelton Moody followed suit and moved his Magnolia Pharmacy into the remodeled Trask

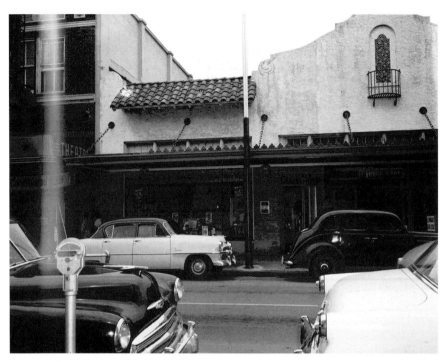

Palestine Collins Hamilton Wright always had flair. After her death, the three children of Palestine and Dr. Olin Wright (Juno, Pallas and Victor) had the Middle Eastern ornate Wright Arcade built in 1926, adjacent to the Young and Moody Building.

Building in 1924, vacating 104 West Reynolds. Also, in 1923–24, Colonel James L. Young, Dr. Calvin T. Young and Moreau E. Moody purchased the northeast corner of Evers and Reynolds from Palestine Wright to construct the glamorous Young and Moody Building, including the new Capitol Theatre.

With the Trask Building to the east and the Young and Moody to the west, the old wooden building at 104 West Reynolds looked bleak. Things changed in 1925.

Olin Wright died in 1923, and Palestine in 1926. The three children of Olin and Palestine Wright (Juno, Pallas and Victor) collaborated to plan the construction of the unique Wright Arcade through the executors of the estate, T.E. Moody and Colonel V.B. Collins. The new L-shaped mall-like building opened in late 1926.

The Wright Arcade was immediately a hit. The well-known and popular Hull Jewelry shop was one of the first tenants. Others included the Dormanys' Arcade Tea Room, whose space was later occupied by Ray Kramer's Photography Studio and, later, Gladys Jeffcoat's Arcade Camera Shop. There was also a barbershop, a real estate office and, on the Collins

# The Wright Arcade: A Unique Story

The unique profile of the Wright Arcade has provided a background of architectural interest over the years, as seen here in this 1956 street scene of downtown Plant City, Florida.

Street side, a popular newsstand and, later, a sandwich shop. Many other businesses and shops have called the Arcade home over the years.

The building was also a good vantage point for viewing the Strawberry Festival or Christmas Parades, especially from the ornate rooftop. For years the Christmas Parade terminated in the central park, which was just behind the Arcade. It is now a parking lot.

When the chamber of commerce was reinvigorated following the end of the Second World War, it set up in the Wright Arcade. The year's biggest event—the reception for the new chamber secretary—was held in the interior open areas in 1946.

The Wright Arcade at 104 West Reynolds Street has gone through several face-lifts, but its unique architecture still stands out as a reminder of its place in Plant City's history.

# Tickel's Bicycle Shop
## A Plant City Favorite

In the early years of Plant City, the bicycle played a major role in transportation. In later years, when the automobile became more commonplace and more affordable, bicycles became an alternative mode of transportation and a major form of recreation.

C.B. Jenkins operated a popular bicycle shop on South Collins Street, across the tracks just south of the center of town, shortly after the turn of the century. It was later taken over by Perry Todd Tickel, doing business as P.T. Tickel & Sons (John and Arthur), and was located about where the popular Hagan's Lunch was and where Snellgrove's Restaurant is in 2006.

Everyone in Plant City knew P.T. Tickel & Sons, and the shop brimmed with bikes and parts. Bicycles filled the front and the north wall. The south wall was fishing equipment, and in the rear was the repair shop. They even built a loft where used bicycles were housed until sold. Edna Tickel Barton and her brother Amos Tickel remembered the place as bustling and full of activity; and they remember the old-fashioned commode with the tank about six feet off the floor and a long chain hanging from it.

P.T. left the business to his sons, and John and Arthur ran the store. When business slowed, they would rotate and take some time off. When it slowed even more, John Tickel went to work for the Kilgore Seed Company, working in the warehouse and making deliveries, where he remained until retirement. Arthur continued to run the business but decided to downsize

# Tickel's Bicycle Shop: A Plant City Favorite

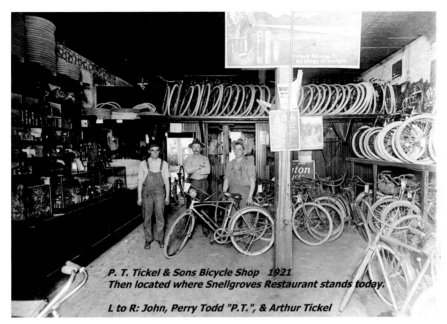

**P. T. Tickel & Sons Bicycle Shop 1921**
**Then located where Snellgroves Restaurant stands today.**
**L to R: John, Perry Todd "P.T.", & Arthur Tickel**

Bicycles were a mainstay for transportation around town in the 1920s. Percy Todd Tickel operated his bicycle shop on South Collins Street just south of the railroad tracks that ran through downtown Plant City, Florida. December 14, 1921.

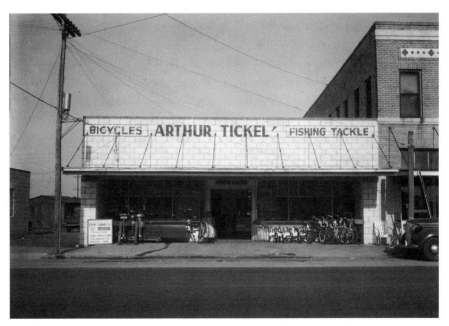

P.T. Tickel left the bicycle shop to his sons, John and Arthur. John Tickel went to work for the Kilgore Seed Company and Arthur Tickel added fishing tackle and other sports equipment to his line of bicycles, shown here in 1947.

and move the business farther south, adjacent to the building that was C.G. Green's Furniture store and later A&N Furniture store. He renamed it Arthur Tickel's Fishing Tackle and Bicycle Shop.

Arthur Tickel was busy and active. He sold a variety of fishing equipment, outboard motors, bikes and trikes, other sporting equipment and even croquet, and along with C.G. Green Co. and Wright Furniture, he sponsored meetings of the Hillsborough County Fish and Game Club. Sometime during the 1950s, Arthur Tickel's shop closed; unfortunately, neither Edna nor Amos could remember the exact date their uncle Arthur closed his business, but until it closed, Arthur Tickel's Fishing Tackle and Bicycle Shop was the favorite place for many in Plant City for many years.

# The Kilgore Seed Company

One of the many businesses that Plant City is known for is the Kilgore Seed Company. Its buildings were prominent both along the tracks between North and South Drane Streets and just west of Collins Street, and the two red brick buildings at 208–212 South Collins Street adjacent to the big curve in the S-track were stoutly impressive.

The story of the birth of the seed company is an interesting one. In 1905, Henry Madison Kilgore journeyed from Texas to Bartow, Florida, where he married Flossie Motes. He then moved to Tampa for a short while, then on to Plant City, where he operated a barbershop.

Flossie Motes Kilgore learned about seeds while working with an uncle in the business in Bartow and began preparing packets of seeds for display and sale out of the barbershop. The seed business flourished and soon Henry Madison Kilgore was pedaling seeds door to door to farmers, first on foot, then with a horse and buggy.

By 1910 Henry and Flossie opened their first retail store, but mail orders had become the bulk of sales, and they amassed a mailing list of nearly forty thousand names for the increasingly popular Kilgore Seed Company annual catalog. Mr. Kilgore became the president of the Southern Seed Association, and by the late 1920s there was a Kilgore Seed Company store in every major vegetable-producing area in the state.

About 1930 the Kilgores sold the business to the Asgrow Seed Company and retired. Henry was elected to the state legislature in 1932 and

## *Remembering* **Plant City**

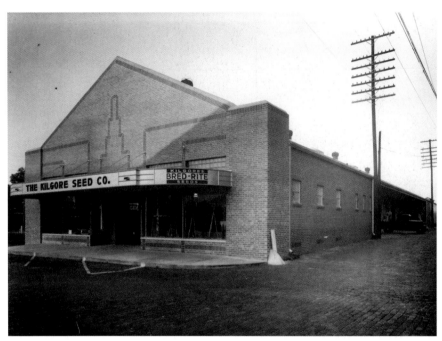

By 1910 Henry Madison Kilgore and Flossie Kilgore had opened their first retail store. This store (date unknown) sat adjacent to the railroad tracks in downtown Plant City, Florida.

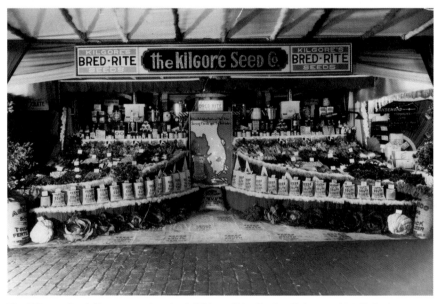

The Kilgore Seed Company advertised "Fifteen Distributing Points and Mail Order; Serving Florida and the West Indies." Indeed, the Kilgore mail-order list included nearly forty thousand names by the 1920s.

## The Kilgore Seed Company

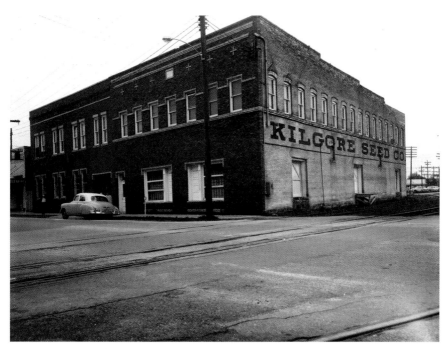

Although the Kilgores sold the company to the Asgrow Seed Company, the name remained the same until 1971, when the Upjohn Company, which had bought it in 1968, changed the name to Asgrow Florida Company. This building sat on South Collins Street just south of downtown Plant City, Florida.

represented east Hillsborough in Tallahassee for two years, and later started Kilgore Hardware and Auto Parts, Inc., in Tampa.

After the Kilgores sold the business, Harry Manee became president and served until he retired in 1966. In 1968 the business (Kilgore and Asgrow) was sold to the Upjohn Company and in 1970 the name was changed to Asgrow Florida Company and, although the management remained the same, the Kilgore name disappeared.

Henry and Flossie had two sons. Ottis Kilgore worked for the Kilgore Seed Company for forty-five years, and Madison Adair Kilgore bought and operated the Kilgore Hardware and Auto Parts Company.

# The Wells Funeral Homes

Plant City has had a variety of funeral homes in its history. One of them, Wells Memorial, has ties that go back to 1896. Here is its story.

Wells Funeral Home was founded in 1896 by the Wells family. Originally it was the Wells Company, a leading furniture and hardware establishment with a funeral branch. About 1926, Wells Funeral Home became separate from the Wells Company, under the direction of G.B. Overton, Plant City's first licensed embalmer.

About that same time, the C.G. Green Co., a furniture company on South Collins Street, also operated a funeral service department. Fred C. Kelley Sr., a major stockholder in the furniture company, took over as the director of what became Green's Funeral Home. The funeral home was then located on the west side of the 100 block of South Evers Street, next to Dr. Black's office, which was on the corner just off the downtown area.

Sometime around 1936 the Wells Funeral Home and Green's Funeral Home were merged under Fred Kelley Sr. and family. Kelley then purchased the former Knight-Wordehoff home and moved it from the northwest corner of Reynolds Street and Wheeler Street (State Road 39) a half-block to the southwest corner of Mahoney and Wheeler Streets, fronting on Mahoney. After extensive remodeling, the big house became Wells Funeral Home.

The story picks up at this point with Lacey McClellan. A Florida native, Lacey McClellan was born and raised in Fort Meade, Polk County, Florida. As a high school student, McClellan participated in the Diversified

## The Wells Funeral Homes

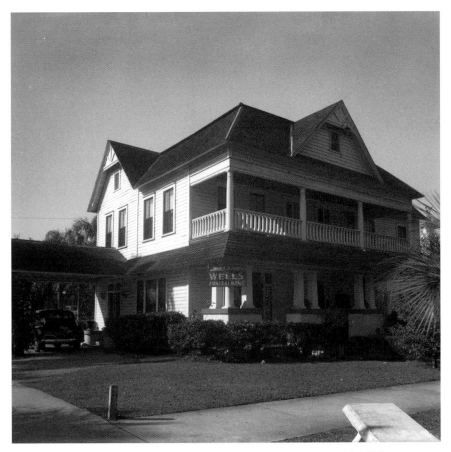

Mrs. June (Collins) Knight's first boardinghouse (circa 1890s) became the H.B. Wordehoff house. Fred Kelley Sr. bought it and moved it from where it sat facing Reynolds Street (across from where the post office now sits) a half-block north to the southwest corner of Mahoney and Wheeler Streets. It was then remodeled as Wells Funeral Home, probably sometime in the early 1940s. This photo dates to about 1958. The house was razed in 1975.

Corporate Training (DCT) program in Fort Meade and worked part-time with the funeral home and ambulance service there. Following graduation, McClellan undertook a three-year apprenticeship at the funeral home in Fort Meade. He then attended a twelve-month program in Dallas, Texas, and received his certification as an embalmer.

After another year of internship, McClellan became a certified funeral director. He returned to Florida and took up residence in Plant City in 1960 and joined the staff of the Wells Funeral Home, which was then owned by Mr. and Mrs. Fred Kelley Sr. and Mr. Fred Kelley Jr.

After Fred Kelley Sr. passed away, Lacey McClellan became a partner with Mrs. Fred Kelley Sr. and Mr. and Mrs. Fred Kelley Jr. in 1965. Later,

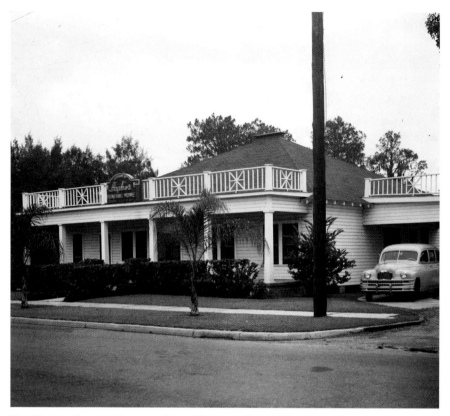

The Hopkins Funeral Home, on Plant City's east side, as it looked in 1949. It was later bought by Barry and Joe Newsome and operated as the Colonial Funeral Home under the direction of Forest Haynes. Lacey McClellan bought it for Wells and it became the Wells Colonial Funeral Home.

Fred Kelley Jr. retired and McClellan became the sole owner. In the early 1970s, McClellan purchased the old Alsobrook House on North Evers Street, across from the 1914 high school, with the intent of building a new funeral home there. Rather than raze the old house, Victor Smith, the previous owner of the property, moved the house a mile west to its present Whitehall Street location. McClellan decided not to build there and later sold the property to the First Baptist Church.

McClellan then purchased the former Hopkins Funeral Home, which was then owned by Barry and Joe Newsome and was operating as the Colonial Funeral Home, under the direction of Forest Haynes. This became the new office for Wells Funeral Home and the name was changed to Wells Colonial Funeral Home. In the 1970s, McClellan also purchased the funeral home on West Reynolds Street that had been operating under the name of Haynes, Griffin, and Ham. He changed the name to Memorial Funeral Home and

remodeled the facility. McClellan operated both funeral homes for a couple of years before merging them (Wells Colonial and Memorial) in the early 1980s under the new name of Wells Memorial Funeral Home. The business was consolidated at the West Reynolds Street site, where it continues to operate today, in 2007. The old house at Mahoney and Wheeler Streets was razed in 1975, and the property became part of the City of Plant City and the new city hall building was constructed there about 2003.

McClellan has since sold the business to Pierce Brothers, who were merged with SCI (Service Corporation International) in about 1991. Lacey McClellan continued to serve as a funeral director, area vice-president and consultant.

# New Hotel Plant Reflects Civic Pride

After the railroad began running, and even as it was being constructed, rooms were sought after by workers and travelers alike. Plant City had a number of rooming houses, room and board operations and hotels over the years. The McLendons' Plant City Hotel was the first hotel, followed by the Robinson House, the Blocker House, the Florida House and others mostly forgotten. One of the first large hotels, the Tropical, was built by W.F. Burts in 1888 at the northwest corner of Reynolds Street and Palmer Street. Later, under the operation of his daughter, Ella Burts Strickland Crum, it was expanded and renamed the Roselawn. It was the most outstanding hotel in the area. Following that, the Hotel Colonial was opened in 1911 at the downtown corner of Reynolds Street and Evers Street.

The first major project of the new East Hillsborough Chamber of Commerce, chartered in 1924, was the construction of a hotel to serve the needs of the Plant City clubs, organizations, businesses and residents. In less than two years, the hotel company drew three hundred stockholders and raised $500,000—all local money. When the one-hundred-room Hotel Plant opened in November of 1926, occupying the full city block bounded by Reynolds, Evers, Mahoney and Wheeler Streets, the newspaper headline read, "Throngs Attend Opening of Hotel Plant." The paper called it a turning point of civic progress and civic pride. The sign in the lobby proudly greeted guests: "Hello Guests and Howdee Do, the Hotel Plant belongs to

# New Hotel Plant Reflects Civic Pride

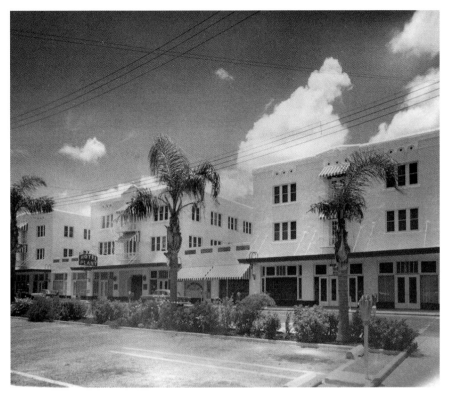

Boasting over one hundred rooms, the new Hotel Plant opened in downtown Plant City along U.S. 92 in November 1926. It was financed entirely by the community and was the pride of Plant City for over the next three decades. This photo shows the east side of the building in 1956.

you; All is yours that you like the best; You're at home now; Welcome guest." The hotel was operated by Ben and Lois Rawlins.

In addition to the beautifully furnished guest rooms on the second and third floors, many with private baths, the hotel boasted two electric elevators with full-time operators. The hotel also featured the Strawberry Dining Room and a smaller north side dining room for club meetings. Ladies' events were frequently held in the plant-festooned second-floor sun parlor.

The Hotel Plant's first floor was fully occupied and included such commercial activities as the Plant City Motor Club, a barbershop, a beauty parlor, a ladies' dress shop, a branch of the County Tag Office (for automobiles), a cigar and newsstand, a gift shop, the Suwanee Ice Cream Company and the office and showroom for the Plant City Public Service Company (which later became Tampa Electric Company).

Virtually all the important events occurred in, at or around the Hotel Plant. Civic club meetings and banquets, official receptions, wedding

The Hotel Plant included this dining room, shown here in 1958, and two other banquet and meeting rooms. Opened in 1926, it was the banquet hall and meeting place in town (serving the Lions, Kiwanis and Rotary) for over thirty years.

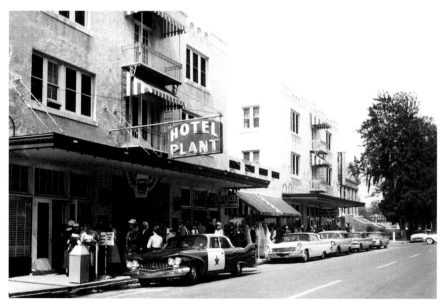

The Hotel Plant's several dining rooms filled up for the Strawberry Festival's Parade Day Luncheon, shown here in 1960.

## New Hotel Plant Reflects Civic Pride

receptions, the Strawberry Festival Parade Luncheon and more all were held at the Hotel Plant.

By the mid-1960s the hotel had seen its better years and was in need of repair and upgrading. It was purchased by Hillsboro Bank, demolished and replaced with a new bank building in 1966. It perhaps is no coincidence that the closing of the grand old hotel followed a change in driving patterns, as Americans took largely to the new interstate highway system and avoided traveling through small-town America's business districts.

# The Coca-Cola/Pollock Building

The old Coca-Cola Building at the corner of Baker and Pennsylvania Streets in Plant City, Florida, now sits vacant and is doomed for demolition. It's a building that once was much admired by Plant City's residents. They would slow their vehicles along the Baker Street route as they approached the Coca-Cola Building to stare up at the enormous Coca-Cola bottle on display there. It hung and tilted at a forward slant on display from the building's upper front structure.

Ed Dudley, one of Plant City's lifelong residents who is now a field supervisor for Plant City, recalls the huge Coca-Cola bottle. He recalls that it must have been about six to eight feet long and approximately two to three feet in diameter. He also remembers how as a young boy he used to watch through the large picture window (now boarded up) as the countless Coca-Cola bottles moved along the assembly line on their way to their cases and cartons. The assembly line had been established there purposely for public view.

Mr. Randy Hardy, branch manager for Coca-Cola, explained that back in the 1930s the Coca-Cola Company permitted each city or town to acquire, through a franchise agreement, their own independent bottling company. He told us that Plant City's franchise was repurchased by Coca-Cola corporate in the early 1960s.

# The Coca-Cola/Pollock Building

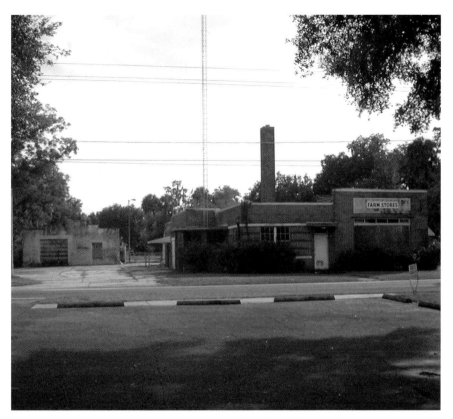

Jim Henderson ("Coca-Cola Jim") acquired the Coca-Cola franchise in 1914. His business expanded and he moved from downtown Plant City to this newly constructed building in about 1939. A large Coke bottle hung from the front of the building until about the mid-1960s. James T. Pollock bought the building in 1966–67 and it became the home of one of his businesses, PaceMaster Oil Corporation. Pollock later sold to Farm Stores, who eventually closed the building.

It was Mr. James William Henderson who established Plant City's independent bottling company. Mr. Henderson, a business and civic leader in Plant City from 1914 until his death in 1948, was a native of Maysville, Georgia. Born January 12, 1872, a son of Andrew Walter and Pelona Ann Lipscomb, he was one of eight brothers who came to Tampa in the late 1890s and entered into the business life of the community.

Mr. Henderson operated a harness and wagon business in Tampa until the automobile became popular. Following that, through his eldest brother, Thomas, Mr. Henderson ("Coca-Cola Jim," as he was later called) became interested in the new soft drink of the day and acquired the franchise to bottle and sell Coca-Cola in Plant City. He moved to Plant City in 1914 to establish the infant business and operated it until two years before his death.

## *Remembering* **Plant City**

Jim Henderson established Plant City's Coca-Cola Bottling Company in a downtown building at the corner of what was Haines and Evers Streets, where B&B Factory Outlet is located today (2007). Because of the business's growth, Mr. Henderson needed a larger facility and had the bottling company's new home constructed at the southeast corner of Baker and Pennsylvania Streets. Work started on the building on November 28, 1938. Mr. Henderson sold the building and business in 1946 to his nephew, Frank Henderson, who operated the business until the parent Coca-Cola Company repurchased the franchise from him in the early 1960s. The building was then closed.

The Coca-Cola Building was rescued from its abandoned state in 1966–67 by Mr. James T. Pollock, and before long the building became known as the Pollock Building, the home of PaceMaster Oil Corp.

Mr. Pollock began his career in the oil distribution industry in 1960 as a commissioned agent for CitiService, now known as Citgo. Mr. Pollock sold diesel fuel to citrus growers, who burned the fuel in their groves during Florida's brief, but damaging, freezes to protect their citrus trees.

Mr. Pollock also sold kerosene, a product that was in high demand during that era. He eventually gave his first kerosene route to Mike Sparkman, and then sold Sparkman the kerosene to supply his route. Mr. Pollock became an independent operator in 1964, forming the PaceMaster Oil Company. After settling the company into the building at Baker and Pennsylvania Streets, PaceMaster Oil Company became the parent to other new businesses, including Speedee convenience stores. One of his first stores was located on the south side of Calhoun Street, near the railroad tracks, where a custom glass company now operates.

Mr. James Henderson and Mr. James Pollock were strong business leaders, as well as generous community leaders. The economic impact from the businesses they developed and the jobs they created was indeed a major contributor to Plant City's growth and prosperity.

The Coca-Cola/Pollock Building again sits empty and silent, waiting to be razed.

# Badcock Furniture Celebrates "A Century of Success"

In the late nineteenth century, many immigrants traveled to the United States of America looking for the opportunity for a new life. One was the Englishman Henry Stanhope Badcock, who sailed to New York in 1889 while in his early twenties. He left New York and headed for Florida, taking in first Jacksonville, then Bushnell, Fort Meade and Mulberry.

While in Bushnell, Badcock met Hattie Omah Vaughan, whom he wed in Alabama in 1896. The Badcocks bought the general store in Fort Meade, Florida, where he worked, and in 1904 moved to Mulberry—which was about to experience the dramatic growth brought about by the discovery of phosphate. That was the beginning of the Badcock furniture business, now the W.S. Badcock Corporation, and the slogan, "Badcock Will Treat You Right," became the guiding principle at that time and continues to this day.

Interestingly enough, as other furniture storeowners and operators did, Henry S. Badcock sold coffins in his store and was a certified undertaker.

Henry and Hattie's son, Wogan Stanhope Badcock, was born in 1898, graduated from Mulberry High School in 1915, served in the U.S. Army during World War I until 1919 and attended the University of Florida. But furniture was in his system, and he returned to Mulberry. He bought out his father's Mulberry store in 1920 for $9,000.

In 1925 Wogan married Evelyn Clark in Mulberry and they had three children, Evelyn Marie, Maida Frances and Wogan Stanhope Jr. Wogan

## *Remembering* **Plant City**

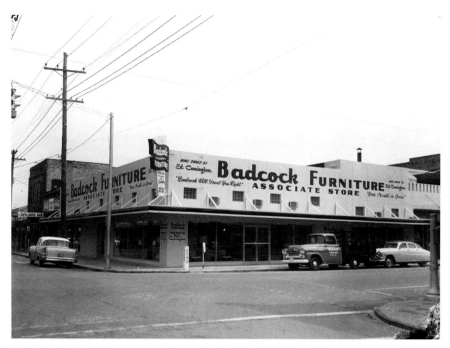

The Badcock Corporation had humble beginnings in a general store in Fort Meade, Florida. Henry and Hattie Badcock moved to Mulberry, Florida, in 1904 and started in the furniture business. In the 1930s Badcock changed its brand stores to a franchise operation; Ed Cunningham had the first Badcock Furniture Store in Plant City (1958 photo), and under Coleman Davis it continues to operate to this day in a new location.

Sr.'s parents, Henry and Hattie, moved to Plant City in the late 1920s and lived in a two-story house on the historic Roux Street.

Badcock incorporated in 1926, and continued its growth through the Depression years and in the 1930s had five stores, a furniture repair shop and several small warehouses. In 1937 Badcock entered the mattress business, buying the Polk County Mattress Factory. By 1943 the W.S. Badcock Corporation boasted fifteen stores.

Maida Frances Badcock and William Knox Pou were married June 15, 1953. They met while Maida was a second-grade teacher in Plant City and Billy was a lab chemist for the W.R. Grace Phosphate Company. Not long after, Billy joined the Badcock Corporation as executive vice-president, safety director and personnel manager. Maida Badcock Pou and the late Billy Pou were active in civic affairs in Plant City and members of many organizations, including the Pioneer Group at Plant City Photo Archives, Inc.

In the 1930s, Badcock changed its mode of operation and branch stores were changed to franchised dealers. Ed Cunningham had the first franchise for the Plant City store, then located at the southeast corner of Collins

## Badcock Furniture Celebrates "A Century of Success"

Street and Haines Street (now MLK), and he kept it until his son-in-law, Horace Andrews, took it over in August 1958. It was later moved to South Evers Street and operated by Coleman Davis.

Bill Pou Jr., son of Maida Badcock Pou and Billy Knox Pou Sr., joined the corporation as executive vice-president of retail operations, overseeing the company's 355 dealers and corporate stores in a number of states. He had served as an associate dealer since 1980, owning both the Haines City and Winter Haven North stores in Florida.

The Badcock Corporation is proud to have celebrated its century of success.

# C.R. "Jack" Hooker and Hooker's Department Store

The building most associated with Hooker's Department store opened at the northeast corner of North Drane Street and Collins Street in 1921 as Farmers and Merchants Bank. The bank closed in 1927. It was reorganized in 1930 as the Citizens Bank, but closed permanently shortly after. During this time it was being eyed from across the street.

Clarence Ray "Jack" Hooker was born November 18, 1907, in Turkey Creek, the youngest of five children, and attended school in Turkey Creek and Plant City, graduating from Plant City High School in 1928.

While in high school, Jack Hooker began his merchandising career working at the Strickland Store at the northwest corner of Collins Street and North Drane Street. He later worked at the stores of J.L. Crews and J.W. Cowart. After graduation he began working for Rogers and Middlebrooks Department Store on South Collins Street and remained there until 1940.

Jack Hooker opened Hooker's Department Store on North Collins Street in January 1940. He expanded in 1943 and purchased the Farmers and Merchants Bank Building for $1,600, thus establishing himself as a major retailer. Hooker's Department Store was a mainstay and a prominent fixture of the "downtown" Plant City scene for years.

Like other downtown establishments, Hooker's was open late on Plant City's busy Saturday nights, when residents from far and wide, and virtually

# C.R. "Jack" Hooker and Hooker's Department Store

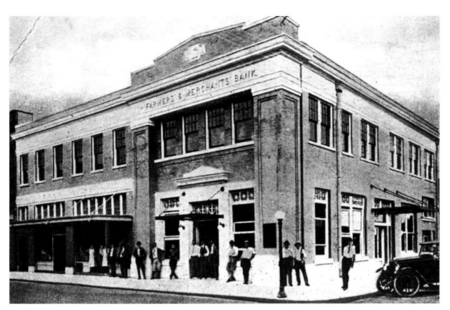

Wesley B. Herring, who was a successful pharmacist and businessman, helped organize the Farmers and Merchants Bank in 1920–21. It was reorganized as the Citizens Bank about 1930 and closed a number of years later.

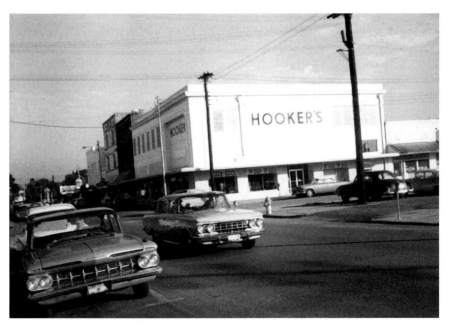

C.R. "Jack" Hooker learned the retail business early, beginning while still in high school. He opened his own store in 1940, when only thirty-two, and bought the former Farmers and Merchants Bank building in 1943 and established Hooker's Department Store as a major downtown destination.

every farm family, congregated there to shop, dine, go to a movie theatre, meet friends and catch up on local news.

Active in his community, Jack Hooker served six years (1947–1952) on the Plant City Commission and was president of the Plant City Kiwanis, president of the Downtown Merchants Association, a director of South Florida Baptist Hospital since its beginning and a director of the First National Bank in Plant City. In 1946, as a director of the chamber of commerce, Hooker was one of the chamber representatives welcoming the new executive secretary, Bill Barbour, with a dinner at the Hotel Plant and a reception held at the Wright Arcade, then the site of the chamber office.

In 1929, C.R. "Jack" Hooker and Lennie Opal Jenkins were married. They had three children. Their second-born was Gerald R. Hooker, who also became active in civic and business affairs, and he served on the city commission for nine years (1966–1974) and as mayor in 1969, 1970 and 1973. He was also a recipient of the Plant City Jaycees Good Government Award. He married Delores Kay Harrell in 1958.

In the 1960s and 1970s, downtown businesses began drifting south on Collins Street and the "downtown" slowly withered. McCrory's, Publix, Sears, Grant's and more were now at the new Plant City Mall. Hooker's Department Store morphed into Thorpe's P.C. Flea, and later, after a facelift, became Frenchman's Market, another version of an indoor flea market, antique, consignment and miscellany shops.

The old building, which opened in 1921 as Farmers and Merchants Bank and for years proudly served Plant City area residents as Hooker's Department Store, is now undergoing another change and is projected to become an operation center for the Church of Scientology.

# The Rayburn Potato Business in Plant City

The Plant City area has been an agricultural center since its beginning. Among the many crops the area is known for are strawberries, okra, cucumbers, beans, bell peppers, citrus, tomatoes and a number of others. But there is not much heard of the potato production and distribution in east Hillsborough.

Although the actual production of potatoes is not near the top of the produce list, potatoes are an important commodity and there are many growers and dealers in the Plant City area.

One of the companies that was heavily into the potato business in Plant City's past, buying, processing, packing and distributing the much demanded vegetable, was the company operated by the Rayburn brothers.

Herman and Hershel Rayburn began the Ready Peeled Potato Corporation in 1951, which was founded to meet the restaurants', institutions' and chain stores' demands for ready-peeled potatoes. It was located at 206 North Drane, at the corner of Wheeler and North Drane Streets, just off the main thoroughfares downtown. The building was in prominent view of visitors to the central business district. The Rayburn brothers' business was there as late as 1965, but later moved to the State Farmers Market, which was established in 1939 for the express purpose of shipping, processing and marketing produce.

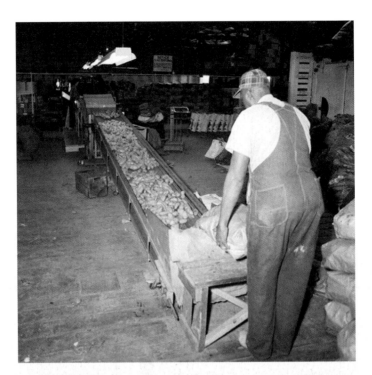

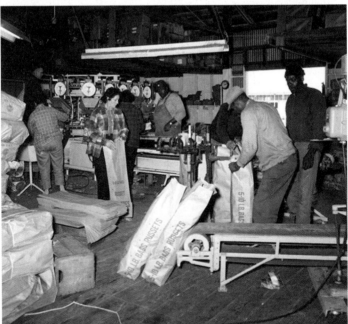

After carefully picking, selecting, washing and culling at Rayburn Brothers Potato Company, the potatoes move quickly down the conveyor belt to the bagging section, shown here in 1964.

# The Rayburn Potato Business in Plant City

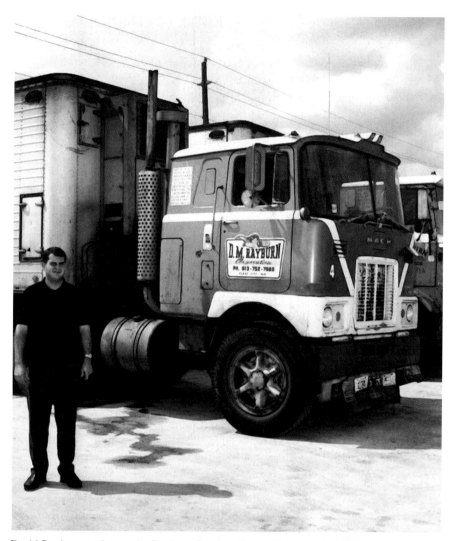

David Rayburn took over the Rayburn Brothers Potato Company in 1967, renaming it D.M. Rayburn Corporation. By 1969 the company was operating as Midland Potato and was sold to Mid-State Potato in 1975.

The Rayburn Brothers Potato Company processed thousands of pounds of potatoes and several other products, including tomatoes and corn. They packed "select tomatoes," "Coach" potatoes, "Circle H" brand, "Bakers Baked Potatoes" and several other brands.

The business operated under several names at different times, including Ready Peeled Potato Corporation, Rayburn Brothers Prepack Potato Company, Rayburn Brothers Potato Company and in 1967 the D.M. Rayburn Corporation. After a fire at the Farmers Market destroyed several

businesses, including theirs, they moved to 902 South Alexander Street, across the street from the old Scotty's, and built a new plant adjacent to the State Farmers Market. About this time other large potato processing corporations were beginning to operate in Plant City, including Midland Potato. By 1969 the Rayburn potato operations were operating as Midland Potato Company at this Alexander Street address. The Rayburn brothers' potato business was sold to Mid-State Potato in 1975.

# Everyone Remembers Donna

Hurricanes have traveled through central Florida and Plant City a number of times in our history, with several of them in 2004—the terrible sisters Frances and Jeanne. But none compares with Hurricane Donna, which roared through Plant City on Saturday, September 10, 1960.

Every Plant City resident of 1960 has a story to tell of where he or she was when Hurricane Donna slammed into the small city on that sultry summer day. When the winds suddenly came, trees were toppled and people were blown over and held desperately to their cars or porches or trees or anything within reach. Travel was virtually impossible, power was out everywhere and emergency crews were scrambling to answer whatever calls they could.

Traveling from the southwest to the northeast, in a similar path to that of Hurricane Charley in 2004, Donna entered central Florida as a Category 4 hurricane and exited toward Daytona Beach as a Category 2, with winds reaching over one hundred miles per hour and dropping a huge amount of rain along the way.

The flooding in Plant City was perhaps the worst in modern memory. Areas that had never flooded before were inundated with a deluge of storm water as Donna took her time crossing the low-lying central Florida lands. The accompanying photos tell some of the story of Donna—the hurricane that will never be forgotten.

## *Remembering* **Plant City**

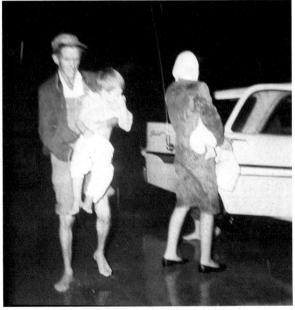

*This page and following:* On Saturday, September 10, 1960, Hurricane Donna rushed into central Florida with a fury, with winds over one hundred miles per hour and a literal deluge of water. Plant City residents had not seen anything like this in years.

## Everyone Remembers Donna

# *Remembering* **Plant City**

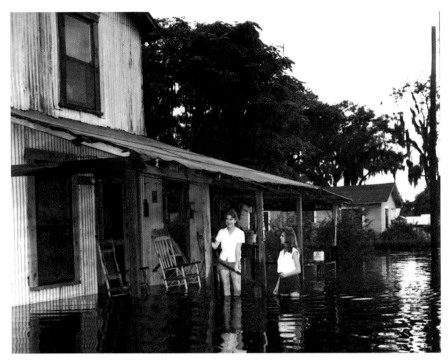

In the aftermath of Hurricane Donna, September 1960, Plant City residents do their best to navigate the streets and yards.

Throughout the city, people were stranded in homes and workplaces as power was out virtually everywhere, including much of South Florida Baptist Hospital, and the highways and byways were impassable. And the rains continued. In south Florida, Donna dropped a foot of rain; Plant City did not fare any better. After the floodwaters receded and cleanup could begin, area residents worked well into October to repair buildings and property and to recover from the devastation wrought by what is considered one of the most destructive hurricanes in Florida's history.

Hurricane Donna is the fifth most severe hurricane in Florida's history. It registered 930 millibars of pressure (27.46 inches on the barometric scale); carried sustained winds of 140 miles per hour, with gusts of up to 200 miles per hour; and had a 13-foot storm surge. Both Hurricanes Ivan and Jeanne registered 947 millibars of pressure at landfall. Nicknamed the "Killer Hurricane," Donna left the coast of Florida, regenerated, slammed into North Carolina and continued up the coast to impact every Atlantic Coast state up through New England with 100-mile-per-hour winds and a relentless rainfall.

# Fire
## A Community's Nemesis

Fire: A word justifiably banned from frivolous use in crowded places; a word that means devastation. A word that struck fear in the hearts of early settlers and residents of Plant City, and rears its ugly head even today.

Fire had nearly destroyed Plant City more than once. And many of the beautiful historic buildings we see today owe their brick construction to the appetite of past fires for buildings built of wood. In 1914, when the newly constructed Hillsboro State Bank was erected on the corner of Collins and Reynolds Streets, that area was known as the "brick block."

Perhaps the worst of the disasters came in 1907, when the fledgling city was struck by two devastating fires, one in July and the second in October. These two fires all but wiped out the town. The July Fourth fire destroyed one of the buildings owned by W.B. Herring, at the southwest corner of Reynolds and Palmer Streets. It had housed the town hall, where council meetings were held and town records were kept—until they were lost forever to the fire.

The October 1907 fire was a wildfire and spread over the entire south side, leveling two entire business blocks. Fourteen businesses, the city jail and five dwellings were all destroyed. Gone, too, was the Plant City Opera House, which was on the second floor of the Herring Drug Store and had been the site for many local events. (Following the fire, the Opera House was moved to the third floor of the Mays Building at the corner of North Drane

## *Remembering* **Plant City**

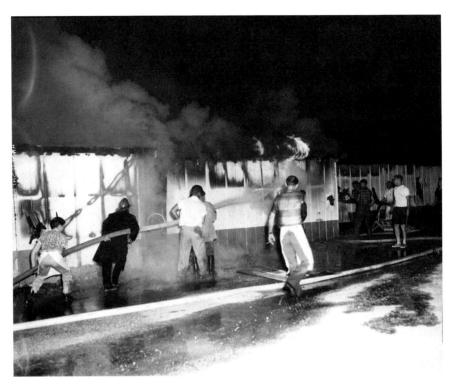

Fire has long plagued Plant City buildings and in 1907 almost destroyed the downtown area. On September 5, 1959, fire consumed the popular Shuman's Market, on the east side of Plant City.

and Evers Street. It burned to the ground in 1915. The Wells Building, which replaced it, serves today as an office building.)

Following the painstaking demolition and cleanup, Samuel E. Mays rebuilt at the southwest corner of Palmer and South Drane Streets. The building later became Black's Department Store and in 2007 serves as the local community bingo hall. Mays used brick. So, too, did Wesley B. Herring, as he rebuilt the drugstore on the southeast corner of Collins and South Drane Streets. (South Drane was later renamed J. Arden Mays Boulevard.)

To meet the growing demand for brick, Colonel James L. Young was involved in establishing the Plant City Granite Brick Company in 1906, where he served as vice-president, secretary and general manager. Most of the brick buildings constructed in Plant City immediately after the 1907 fires used bricks from this plant.

In 1910, in another of the series of fires that have haunted Plant City, the recently rebuilt Herring Drug Store was a fire victim. So, too, was the *Plant City Courier*, which was then housed on the second floor of the Herring Building. The flames destroyed valuable papers and irreplaceable

# Fire: A Community's Nemesis

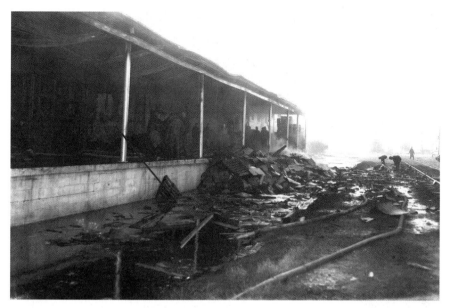

Southland Frozen Foods began its operations in Plant City in 1943, then expanded many times, constructing a large modern processing plant in 1949. This arsonist's fire of December 1954 almost destroyed the plant, but Southland rebuilt and expanded again.

copies of the *South Florida Courier* and the *Plant City Courier* dating back to 1884. Herring rebuilt again, and that building in 2007 housed the Whistle Stop Café.

Coincidentally, in 1911 a "midnight fire" destroyed the Plant City Granite Brick Company. It was later succeeded by the Roux Composite Brick Company, which manufactured and sold five million bricks in 1913 alone. Plant City had seen many tragic fires by 1914, and bricks became the absolute choice of building materials, but not a guarantee of indestructibility in the face of roaring flames.

Fire has wreaked havoc in the community of Plant City but, in spite of the destruction and devastation, the city continues to come back, to rebound and rebuild. This spirited community will continue to surmount the obstacles thrown in its way.

# Plant City and Baseball
## A Long and Loving Relationship

Plant City has long been known as a sports town, appreciating sports of all types and varieties. But perhaps no other sport stands out like baseball. Baseball and strawberries have been married for many years. When the Cincinnati Reds moved from Tampa they chose Plant City for their spring training headquarters and remained there for a decade. That stadium then became the home field for the International Softball Federation.

Of the many stories about baseball in Plant City, two come to mind as unique. One is the story of Rip Sewell and the other is the Robinson family baseball team.

Truett Banks Sewell was born in Alabama and grew up playing organized and sandlot baseball, and playing it well. He was recruited and came to Plant City in 1936 to play for the Buffalo Bisons in the International League. Buffalo was considered the best triple-A team in the country. While in Plant City, Sewell met and married Margaret Abbott (the daughter of the chief of police), who he met in an ice cream parlor in the Hotel Plant. He made Plant City his home for the rest of his life.

Truett Sewell had several nicknames, but none stuck like the name his wife gave him: Rip. Rip Sewell joined the Pittsburgh Pirates in 1938 and stayed with that club until 1949, pitching over 2,100 innings, winning 143 games, losing 97 and playing in several All-Star Games.

# Plant City and Baseball: A Long and Loving Relationship

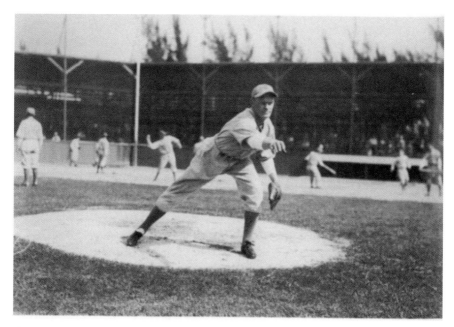

Truett Banks "Rip" Sewell was a big, strong kid who grew up on a farm in Alabama and could throw the ball amazingly well. He signed with the Pittsburgh Pirates in 1938 and over the next ten-plus years pitched over 2,100 innings. After a hunting accident in 1941, he became famous for his blooper ball.

After being shot by a twelve-gauge shotgun in a hunting accident in 1941, Sewell developed a new pitch because of his shattered toes. His "Ephus Ball," or blooper, would rise twenty-five feet in the air and then drop down right over the plate. Batters hated that pitch, and it became famous in the 1946 All-Star Game played at Boston's Fenway Park.

In the eighth inning of a long, hot game, Sewell was sent in to liven up the game. Up to bat came "Mr. Baseball," Ted Williams. Williams called out to Sewell and said, "Don't throw that pitch." Rip said, "You're gonna get it." And he did. Williams fouled the first blooper off the tip of his bat and then took a fastball for strike two. He shouted to Sewell not to throw "that pitch" again. Rip Sewell said again, "You're gonna get it." He did again. This time the ball rose to twenty-five feet and Williams took a few steps, positioning himself, and clouted the ball into the right field stands. Rip jogged around the bases along with Ted Williams, joking and laughing. The crowd went wild. That was the only home run ever hit off the blooper.

After retirement, Rip Sewell spent the rest of his years in Plant City, golfing and fishing with his friends and enjoying his family. He died in 1989.

The second baseball story is about the Robinson brothers. The large Robinson family had been in Plant City for a long time. Captain Dan

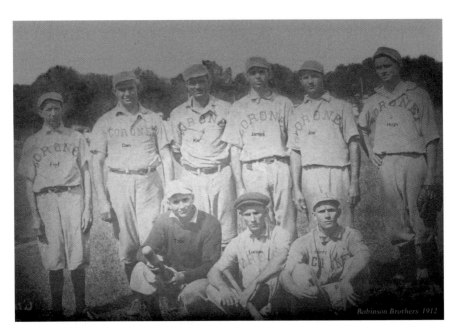

The Robinsons were one of Plant City's many athletic families, but when all nine brothers got together they formed an outstanding baseball team. Here they are in uniforms borrowed from the Coronet Mines team, circa 1912. *Back row, left to right*: Fred, Dan, Kie, James, Joe and Hugh; *front row, left to right*: Tobe, Lucian and Henry Robinson.

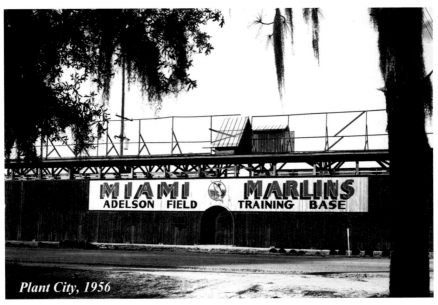

Long before the Florida Marlins took the field, the Miami Marlins minor league team took their spring training at the Adelson Field training base in Plant City. This photo was taken in 1956.

# Plant City and Baseball: A Long and Loving Relationship

Robinson had boasted that he would have a baseball team within his own family, and he did. Daniel Frederick Robinson and Martha Roberts Robinson had twelve children and the nine oldest sons formed their own team. Then, on July 4, 1912, nine Robinson brothers took the field to challenge the Plant City Regulars.

The Robinsons borrowed uniforms from the Coronet team to dress up for the event. On the mound was Hugh, with Tobe behind the plate. Lucian was at first, Jim was at second base, Henry was at third, Joe was at shortstop, Fred was in right field, Kie was in left field and young Dan held court in center field. Sisters Mattie, Sallie and Laura cheered them on. It was a serious battle and a fun time and the crowd roared as Fred chased a long fly to right field, tripped over a potato vine and popped up again with the ball in his glove. It was a hot day and a hot contest, but the Robinsons came up short, losing to the Regulars two to one.

Yes, Plant City has a rich past filled with fascinating stories about baseball, families, athletes and city pride. The Rip Sewell story and the Robinsons are just a touch of the history that lies beneath the surface in Plant City.

# Plant City's Movie Houses Were a Delight for All

Born in the waning years of the nineteenth century, the film industry exploded across America in the 1920s. In Plant City, as throughout the nation, the film industry did not suffer during the Depression. It flourished during the worst years, and continued to hold the central position in American entertainment until being nudged aside by the popularity of television.

In June of 1915, the Star Theatre opened on South Collins Street, just south of Haines Street, but little is known of that theatre. The most popular theatre in Plant City was the Capitol Theatre on West Reynolds Street, just off the center of town in the large Young and Moody Building next to the Wright's Arcade. It opened in 1924.

In the 1930s the favorite themes were escapist, and to escape the gray rigors of the Depression life, people lined up and bought tickets by the droves, nine cents for children under twelve and twenty-eight cents for adults. The cowboy was still a figure of individual freedom in a world in which public events and private lives had become too complex, and audiences flocked to hundreds of low-budget westerns each year.

The State Theatre, which still stands on West J. Arden Mays Boulevard, opened in December 1939, the year of *The Wizard of Oz* and the breathtaking *Gone With the Wind*. This theatre had a balcony and a separate entrance; it was the only one that admitted Plant City's black residents, who sat in the

# Plant City's Movie Houses Were a Delight for All

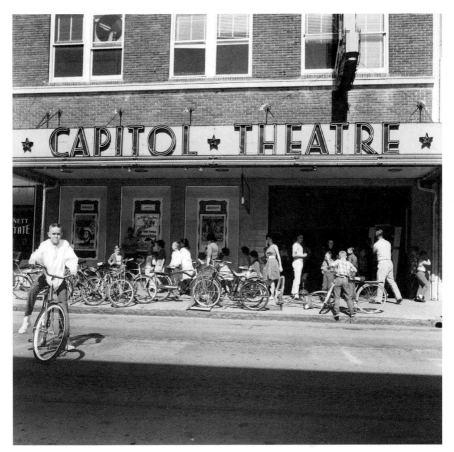

The Capitol Theatre opened in the Young and Moody Building in March 1924 to a large crowd. It continued to be a highly popular downtown movie theatre throughout its life. These bicycles are shown at the Capitol in 1962.

balcony section. Possibly because of the proximity of the two theatres, being but two blocks apart, Cliff King, who had managed the Capitol for some time, was also signed on to manage the State Theatre.

Saturdays were special. Youngsters and teens from the area headed to the theatres on foot or bicycle to catch the latest in the "serial" adventures of Tom Mix, Gene Autry and other western heroes, or Buck Rogers and the science fiction stories. There was no TV, and these serials were fascinating and drew the youngsters back on a regular basis. They were also treated to Saturday cartoon specials with Mickey Mouse and Bugs Bunny, and there were always the Fox News shorts to bring the week's events to them. After the double feature they went to Cone's in the Hotel Plant for ice cream, or to check the latest comics at Harold's News Stand behind the Magnolia Pharmacy.

In 1946 the popular Capitol Theatre concession stand featured popcorn, Hershey chocolate bars and other refreshments.

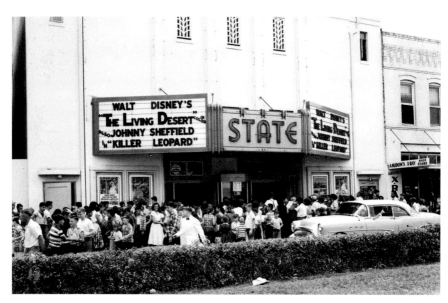

The State Theatre, shown here in 1952, opened in December 1939 and was one of the two downtown theatres until the 1960s. The State Theatre had a separate entrance for black people that led to the balcony.

# Plant City's Movie Houses Were a Delight for All

With time, things change. The Capitol Theatre fell silent and later became the Savannah Restaurant, then Harry's Place and now the entire Young and Moody Building has been renovated. The State Theatre closed and became Bill Gunn's Jewelry Store, and later several people had dreams of bringing it back to life. Their futures are uncertain, but in their day, these movie houses shone brightly.

# Plant City's Own Radio Station

Many Plant City residents fondly remember WPLA, 910 on your dial, as their "community radio station," and it was. First sent out over the airwaves in July 1949, the station quickly gathered steam and also quickly gathered a strong support base.

W.A. Smith and his brothers Ray and Lester owned and operated Smith Brothers Suprex Market, which dated back to 1926. W.A. became interested in the radio business and in gospel music, and he decided to put together his own radio station. With some equipment purchased from WLAK in Lakeland and an Orlando radio station, Smith was able to set up his operations at 1507 South Collins Street and received authorization from the FCC to operate his daytime facility at 1570 kilocycles from sunrise to sunset.

By 1951 the station was ready for its next growth stage and W.A. Smith hired George Friend as station manager. Friend, the brother of local photographer Bill Friend, was a Lakeland native and came to WPLA from WLAK, where he was known for his daily *Man on the Street* interviews. Friend was just what WPLA needed and he managed the station, wrote and recorded commercials and began doing remotes from the downtown auto shows, the Strawberry Festival, political rallies and local businesses' special events.

In 1956 the station was granted approval to move from 1570 to 910kc to reach a larger audience, which it had attained from its extensive coverage

# Plant City's Own Radio Station

Plant City's own radio station, WPLA, celebrated its ten-year anniversary in 1959 and welcomed the community into its studio.

of local activities and from its popular, country and gospel music format. Al Berry joined the station in 1958 and became both a sales representative and an on-air personality.

The station used the UPI Teletype news, called "rip and read," on an hourly basis and carried local news at 12:30 p.m., announcing births, deaths, etc. They continued doing remotes from area events and businesses and reported on the Strawberry Festival, play-by-play high school football games and community issues. When George Friend died of a sudden heart attack in 1968, W.A. turned to Al Berry and offered him the opportunity to be both manager and part owner.

It was about this time that Berry started the *This 'n That* program. It began as a twenty-five-minute daily swap program for people to buy and sell goods. It grew more popular and expanded to one hour. W.A. Smith's son, Ercelle Smith (who liked cattle but not broadcasting), joined the station about 1966 and in 1968 joined Berry in the *This 'n That* format—and the program really took off. *This 'n That* became a two-hour program that perhaps was the forerunner of today's talk shows. It covered local interest,

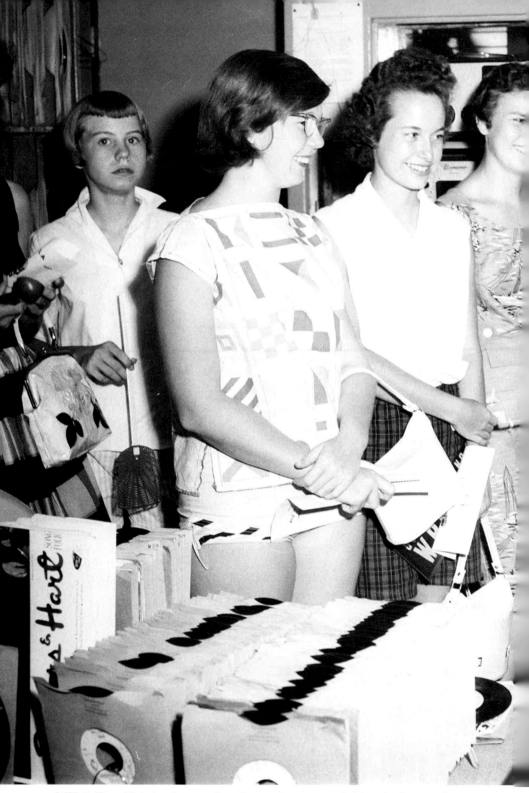

WPLA's Terry Nichols spins records and entertains guests and visitors in the control room during the station's tenth-anniversary celebration in 1959.

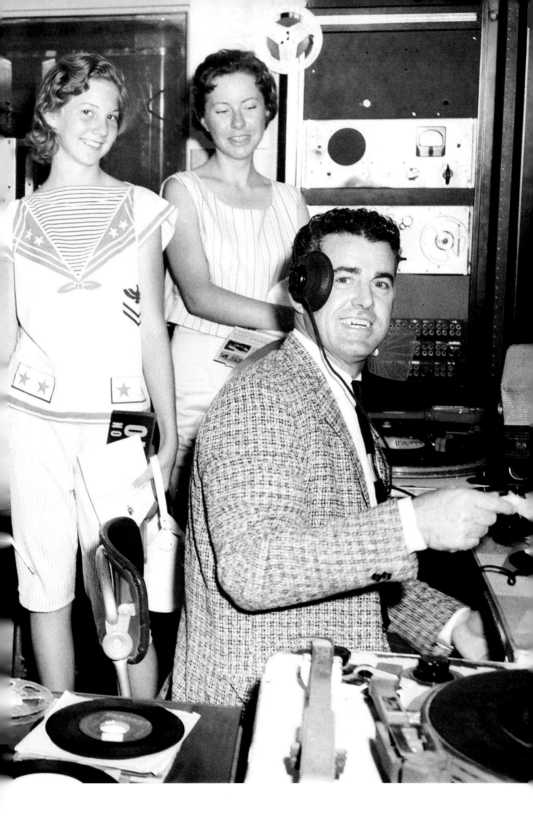

items to sell and community activities. Bert Manzell would call in to play his guitar and sing over the phone. Aunt Maggie, who raised cattle and tanned snakeskins in Springhead, would call in frequently and entertain the listeners with outlandish stories—and she was a storyteller. *This 'n That* became a community icon radio program and retained this popularity for over twenty years.

Over the years many personalities went through that station and WPLA was a beloved community asset. Mary Jim Everidge was perhaps the first female talk show host and her show (1962–68) grew from fifteen minutes to an hour almost overnight. Others who passed through the control room include Terry Nichols, Jack Rushing, Jim Maloy, Joe Penny, Gordon Solie, Steve Smith, Dick Shiflett and many more. To see who else was involved and to read up on WPLA, go to Jim Maloy's excellent website at www.radioyears.com.

Al Berry and Ercelle Smith bought the station from W.A. in 1974 and continued to run it until 1987, when they sold it to Harmon Broadcasting. The Plant City facility was closed in 1994 and the building became a child-care facility and later a hair salon—thus ending the story of Plant City's "community radio station," WPLA.

# Plant City's Schools Over the Years

During most school years, with schools in full session, the students are in full attendance. It wasn't always that way. It was true that Plant City area residents valued education, but the scheduling was sometimes difficult. Most families were dependent on agriculture, and farm tasks came first. Irregular attendance in the early schools was a problem addressed by Frank Merrin, editor and publisher of the *South Florida Courier*, in a front-page story on July 17, 1891. He decried the fact that the public schools were poorly attended.

One way to deal with this became known as the Strawberry School System, where the school term started in the late spring and ended in December to free children to help pick berries and work the fields during the peak of the season. In 1956, the school district decided to abolish the Strawberry School concept and place all schools on the same schedule.

There is evidence of a number of private homes being used as temporary schools in the Plant City area in the early 1800s, and a few public schools had been established as early as the 1850s.

In the Bealsville area, a school was started in the Antioch Baptist Church about 1868, and the residents of the community built a one-room log cabin school in 1873. Other early schools include the Casey School in the Cork area (1872), Springhead (1876), Cork School No. 12 (1877) and the Shiloh School (about 1879). The Cork Academy was established at new

## *Remembering* **Plant City**

Early junior high school education classes and basketball games, such as this one in 1947, were held on the paved court adjacent to the old school buildings, which dated to 1893, 1903 and the most recent one, the concrete stone building, was built in 1909.

Cork in 1876. The primary textbooks used then were the old standbys: the McGuffey Reader, the Blue Back Speller and the Bible.

The first regular Plant City public school was built sometime around 1885. It was a one-room frame school building at the northwest corner of Thomas Street and Mahoney Street, near the downtown area. Professor and Mrs. E.G. Burney were the first teachers.

After a bond issue, a new brick building was erected in 1893 on Wheeler Street, just east of the old school. Population growth continued and, because of overcrowding, a four-room addition was completed in 1903, the year the school graduated its first high school class. In 1909, a separate two-story concrete stone building for high school classes was constructed to the south of the brick school.

With population growth continuing unabated, it was clear that a larger facility was needed. In 1914, the School Improvement Association successfully promoted a $40,000 school bond issue to construct a fine new school on a block of land on North Collins Street, land that had been purchased from Palestine Wright. Taxpayers agreed to a $5 million levy to finance the project. This architecturally outstanding edifice became known as the 1914 Plant City High School.

# Plant City's Schools Over the Years

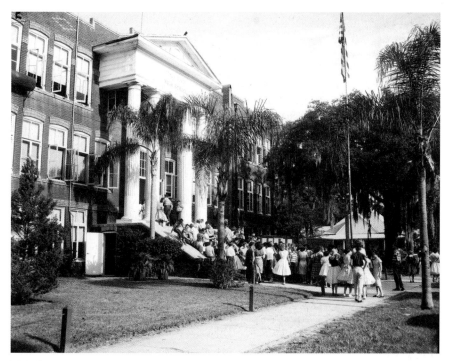

With the completion of the new high school on the west side of town, the old 1914 Plant City High School was renamed and opened its doors as Tomlin Junior High School in 1958. The school was named after Mary L. Tomlin, who was an educator and principal in Plant City for many years. This photograph shows the first day of school in September 1959.

The new school's beautiful auditorium had a seating capacity of about fifteen hundred, and for the next several decades it became the center for community activities. These included performances of all kinds, plays, recitals, lectures and concerts, some sponsored by the Plant City Civic Music Association.

The old Central School on Wheeler Street then became the Central Grammar School. From 1920 on, school construction continued, although it was slowed by the Depression. The Midway Academy was opened in 1920. Esther D. Burney Elementary opened in 1923, and three identical elementary schools—Stonewall Jackson, Woodrow Wilson and William Jennings Bryan—all opened in 1925–26. The Trapnell area, south of Plant City, got a new building in 1932. The William Glover School was constructed in Bealsville in 1933, and was expanded several times in the next decade and a half.

More schools followed. The Midway Academy got additions about 1936 and then split into an elementary, which became Lincoln Elementary (1951), and a high school, Negro High School, renamed Marshall High School in

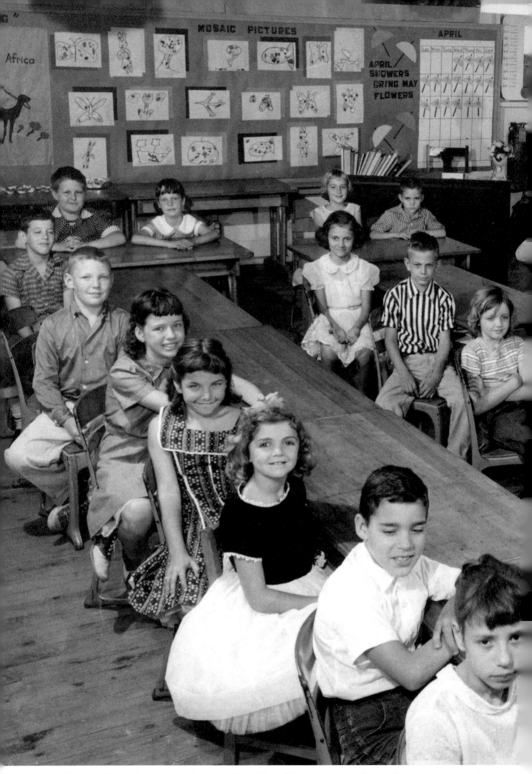

To meet the student population growth in Plant City, a number of schools were constructed over a period of years, including William Jennings Bryan, shown here in 1958–59; Woodrow Wilson; and Stonewall Jackson. All three elementary schools were built in 1925–26.

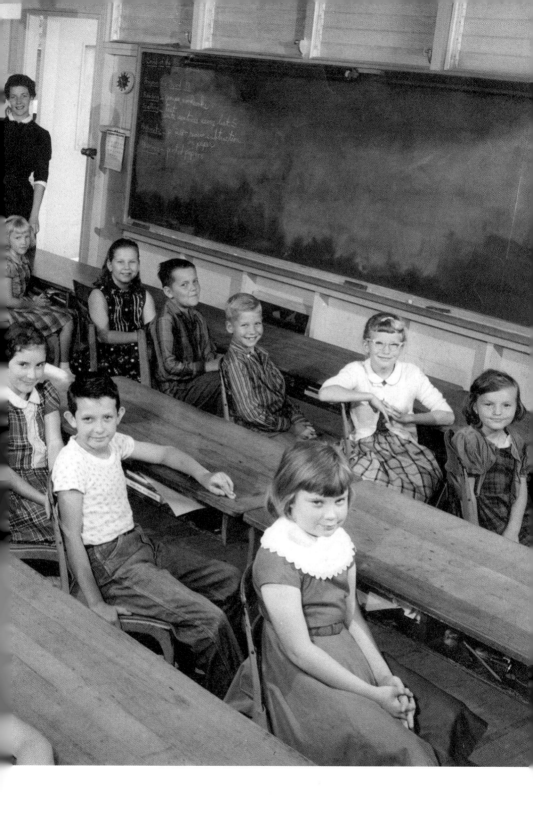

# *Remembering* **Plant City**

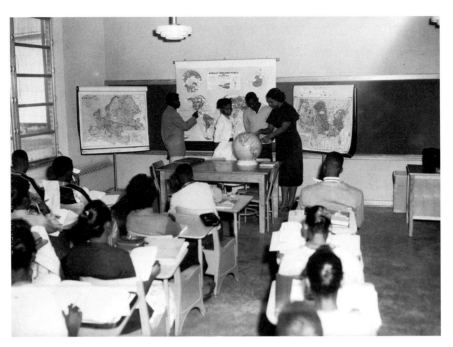

Further student population growth in the black community stimulated the construction of several new schools, including Lincoln Elementary and Marshall High School, shown here in 1958.

1949. Forest Park School followed in 1950, and Simmons Elementary was built in 1951. The new Marshall High School was constructed and opened in 1957, followed by the new Plant City High School on Woodrow Wilson Street. Old Central was demolished in 1958 to make way for a new city hall.

The new consolidated Plant City High School was completed in 1972, and combined the students from the former Marshall High School, Turkey Creek High School and Pinecrest High School. Junior high students transferred to the Woodrow Wilson Street facility, renamed the Mary Tomlin Junior High School, and the former Marshall High became a middle school. The old 1914 Plant City High School was closed. The Hillsborough School District donated the building to the City and it has been used for the offices, archives and museum collection of the East Hillsborough Historical Society.

Plant City has had quite a history in its effort to provide an adequate education to its residents and their children, and although many of the schools are mentioned here, many of the schools are not—that would require a full history. Nonetheless, this is a good example of a typical effort of a small American town to provide for an educated citizenry.

# The Boys and Girls—Men and Women—of Plant City's Greatest Generation

When World War II hit Plant City, "it was like a vacuum that sucked out every man between the ages of eighteen and thirty-eight and shipped him off to war." Betty Barker Watkins remembers it well. She said the town changed almost overnight. David E. Bailey Jr. was chosen as the first married man draftee. Then all the rest were sent off, too. They served in the U.S. Army, Navy, Marines and Coast Guard, and those who couldn't go joined the Home Guard. In one way or another, everyone was involved.

Some came home on leave, if they could get it; some came home to recover from their wounds; some came home after their discharge; and some never came home. The fighting ended in 1945 and the peace treaties followed many years later, but the worst years for America were from 1941 to 1945.

In 2005, sixty years after the end of the war, we at the Plant City Photo Archives felt we needed to honor all those who gave so much and sacrificed so selflessly in order to preserve the liberty we continue to enjoy today. We recognize now that these people changed the world, rescued it from the abyss and gave it back to us.

We asked for photos of those who served, and they answered. The Photo Archives has received over five hundred photographs from Plant City men and women, some still living in Florida and many who are scattered across the country. We had numerous wonderful octogenarians visit our offices to

## *Remembering* **Plant City**

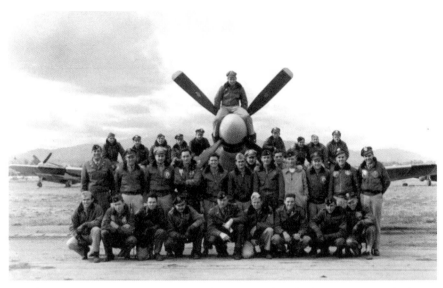

Plant City's young men and women responded to the call and enlisted by the hundreds. Harrison Covington (second row, fourth from left) became a P-47 fighter pilot in the United States Army Air Corps and served in the Pacific theatre. Harrison's brother, Edmond "Ted" Covington, served in the United States cavalry and field artillery in the Pacific.

Serving in the United States Army Company C 327 Medical Battalion, 102$^{nd}$ Ozark Division, Woodrow Wilson Frazier takes a break to write to his wife, Bonnie Evelyn Ham Frazier. He served in Europe and provided medical attention as the American soldiers liberated several concentration camps.

# The Boys and Girls—Men and Women—of Plant City's Greatest Generation

bring us their photographs and regale us with wonderful, sad, enlightening and horrifying stories. After meeting them, the meaning of "the Greatest Generation" becomes immense, very real and deep-felt.

From A to Z they came. Some flew over the hump, from Burma into China, delivering supplies behind Japanese lines. Some flew over the channel deep into German-held territory. Some landed on the beach on D-Day. More than one had his ship blown out from under him. Tales of excruciatingly painful, long, cold marches were all too frequent. We've had individuals and families consisting of as many as four brothers serving concurrently. We've heard disheartening stories of missed opportunities, and glorious stories of reunions in far-off places.

These were and are incredibly wonderful people, and we extend to them our eternal gratitude for what they gave of themselves to give to all of us. They did change the world. Every year on Veterans Day, the Plant City Photo Archives presents its exhibit: a Salute to Veterans in their honor.

# Central Park
## *The Heart of the City*

Since the birth of the nation, the heart of American cities has been their central parks. So, too, in Plant City. Today, the city's activities center upon historic downtown's McCall Park. In the past, they centered on the central park, also referred to as City Hall Park, on Mahoney Street between Collins and Evers Streets, just one block from the center of town.

After the old city hall burned down, civic activities gravitated toward the new city hall (constructed in the early 1920s) at the corner of Collins and Mahoney, and the park was across the street to the south. Behind the city hall was the Masonic Lodge, also a hub of activity then. To the west of the Mahoney Street park was the Hotel Plant, and the park was bordered on the south by the Young and Moody Building, the new Wright Arcade and the Trask Building, which anchored the northwest corner of Collins Street and Reynolds Street.

The annual Christmas Parade always turned north on Collins Street and terminated at the park, where scores of children waited to talk with Santa, sitting on an enormous chair on a wooden stage. The party with Santa was an annual tradition and all the youngsters looked forward to it. All the parades headed for the central park, where a large stage behind the Wright Arcade served for a bandstand, complete with speakers, announcements and so on.

# Central Park: The Heart of the City

City hall provides a good backdrop to the city's central park, shown here in 1954, which had shuffleboard courts on the west side, a grassy area for recreation or events to the east and a stage platform to the north, up against the Wright Arcade Building and adjacent the Young and Moody Building and Capitol Theatre. Across Evers Street to the west was the Hotel Plant, and around the corner was the Hotel Colonial.

When the bands took the stage the people gathered in the park and sat on produce crates donated by local businesses. There were also prayer meetings, civic club activities (such as the Jaycees), veterans' services and many other special events. The Memorial Day Parade was an annual event then, and the American Legion would lead the ceremony, the Gold Star Mothers would be honored and there would be marching bands and the ubiquitous politicians. The park was also a gathering spot and a great site for hotel guests to take an evening stroll after visiting Tony's ice cream parlor in the Hotel Plant.

That all ended when the trees were torn up and the ground was paved over for a much-needed parking lot (1958–59). The Masonic Lodge came down, too, along with the Hotel Plant and city hall (after a brief stint as

Most Plant City celebrations took place at the central park, and the Christmas Parade and Memorial Day Parade, shown here in 1951, terminated here for speeches, Santa Claus or other activities. The park was closed and paved for a city parking lot in 1956.

an annex to the First Baptist Church). Central park was gone. Years later, however, it was replaced by a two-block strip named McCall Park, after former City Manager T.J. McCall. After the old Union Station (the Depot) was renovated and McCall Park was expanded and totally reconstructed, the "central park" concept was reborn, and today this new park has become the city's heart and soul.

# The Bruton Memorial Library

As churches provide the spiritual foundation for the growth and development of a community, and banks provide the capital, it is the public library that is the core of a community's intellectual and cultural life. And Plant City's library continues to stand as a tribute to the people of this community—and to a small, dedicated cadre that made it happen.

There is a quote in the book *Plant City: Its Origin and History* that gives great tribute to the individuals who were the brunt of the driving force to create the public library in Plant City.

> *There is no plaque or marker to say so, but the Plant City Public Library is generally considered a memorial to three women, all past presidents of The Woman's Club of Plant City, the organization which established, sponsored, and operated the library for many years. They are the late Mrs. G.B. (Veronica) Wells, who was president in 1933 when the club established the public library; the late Mrs. Mary Noel Moody, who through the years, sometimes almost single-handedly, kept the library operating; and Mrs. James D. (Quintilla) Bruton, Jr., who determined that their dream of a municipal library should become a reality.*

Interest in a public library dates back to the early 1900s. Although funds from the Carnegie Foundation were available in 1917 and

# *Remembering* **Plant City**

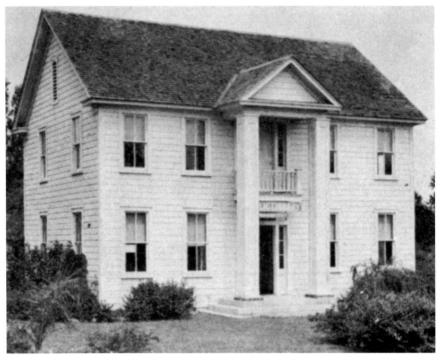

In 1933 the City foreclosed on this house on McLendon Street near Wheeler Street, the site of the current library. The Woman's Club of Plant City, which in 1929 had set up a small club library in the old Central Grammar School, acquired this building to convert it to a joint clubhouse and public library, which it operated through 1959.

numerous citizens volunteered to help and encouraged the city to apply, nothing was done and the city went without an adequate library for another forty-three years.

The Woman's Club of Plant City set up a small club library in 1929 with donated books on a few shelves in their club room in the old Central Grammar School, on the southwest corner of Baker and Wheeler Streets, across the street from Mrs. Wells's home. Some few years later the city foreclosed on a two-story house near the intersection of McLendon and Wheeler Streets, and the Woman's Club paid for remodeling and took over complete responsibility for the building, which then served as a combined clubhouse and public library.

Using funds from the New Deal's Works Progress Administration, in the 1930s, the club hired a part-time clerk for the library. The only financial assistance the city gave was twenty-five dollars a month toward staffing, beginning in the 1940s and lasting until 1959.

In 1956 the city floated a $500,000 general improvement bond and Mrs. Bruton, then serving as president of the Woman's Club, began a campaign

# The Bruton Memorial Library

The Plant City Bruton Memorial Library as it looked in 1963. By 1970 the library had expanded to twice its size and by 2005 it expanded again. In 2007 the city of Plant City again went into expansion/building mode to meet the continuing demands of a growing population.

to have the library included in the city's list of projects. The effort received support from Clay Codrington (editor of the *Courier*), the chamber of commerce, WPLA radio and the people—but the city commission did not budge. They had earlier wanted a swimming pool, and now talked about a new city hall, ballparks, fire station, Winter Visitors' Center—everything except a library. Over two years passed.

Finally, in a move to put down the growing clamor for a library, commissioners called a referendum under the Florida Municipal Library Law, allowing little time for the Woman's Club to mount a campaign to convince the people to increase their taxes. Determined, the Woman's Club redoubled its effort, winning support again from the *Courier* and from the American Legion, Lions Club, chamber of commerce, Pilot Club, Elks Lodge, Shrine Club, junior chamber of commerce, Business and Professional Women's Club, Kiwanis and Junior Woman's Club. In the end, the people prevailed. In an unusually heavy turnout for a local election, the people approved the library levy by a three-to-one majority.

The wife of Judge James Bruton, Quintilla Geer Bruton—after whom the city library is named—served as president of the Woman's Club of Plant City and spearheaded the drive for a municipal library. She served as chairman of the library board as well as the chairman of the Hillsborough County Library Board and chairman of the State Library Board.

# The Bruton Memorial Library

The two-story house, which was the Strickland home when it stood at Haines and Palmer Street prior to being moved to the current library site, and was since converted for use as a public library, was razed in June 1959.

On December 4, 1960, the new Plant City Public Library was dedicated, with the first library board consisting of Mrs. Bruton, chairman; Clay Codrington; Mrs. L.T. Langford; the Reverend Osborne McKay; and Robert Trinkle.

Remarkably, less than three years after the library opened, in 1963 the Book-of-the-Month Club presented the Dorothy Canfield Fisher Award and a check for $1,000 with which to purchase books to the Plant City Public Library as Florida's most outstanding small public library. By 1970, the library had expanded to twice its size.

The facility was later renamed the Bruton Memorial Library for its benefactors, Judge and Mrs. James Bruton, but especially for Quintilla Geer Bruton, whose heart and soul had gone into the development of a library for Plant City for over thirty years.

Although steeped in history, today's library is a state-of-the-art facility. It is the pride of the city and has a support group, the Friends of the Library, and many users and supporters from all walks of life. Because of the continuing growth of the services, programs, resources and demands, Anne Haywood, library director, and the staff and officials of the City began the process of planning for new construction or expansion of the existing structure in 2006 and will implement these plans in 2007 for an even greater Bruton Memorial Library to serve the citizens of Plant City and the surrounding area.

# The Heritage Award
## Two Profiles

The Plant City Photo Archives was organized in 2000 and spent the next several years collecting, scanning, preserving, printing and exhibiting its collection of historic photographs out of small borrowed office space. As the Photo Archives became better known, the organization began holding an annual fundraising event, a soirée titled "An Evening of Picture Perfect Memories."

In its third year of fundraising soirées, the Photo Archives' Advisory Council suggested the presentation of a Heritage Award to an individual who had performed outstanding service to the community in the way of preserving its history and heritage. And so the concept of the Heritage Award was born.

The first year the award was presented it was clear that Mr. David E. Bailey Jr. should be the initial recipient. He and the late Quintilla Geer Bruton had authored the chronicle of the community entitled *Plant City: Its Origin and History*. The second year, the recipient was Mr. James L. Redman, who was a beacon of light in the leadership of the community. These are two of the most respected members of the greater Plant City community.

Here is a brief look at the two men who were the first two recipients of the Heritage Award.

# The Heritage Award: Two Profiles

## David E. "D.E." Bailey Jr.

David E. Bailey Jr. was born in Shady Grove, Taylor County, Florida, in August 1917 to David Elmer Bailey Sr. and Priscilla Browning Bailey. David E. Bailey Sr. was from Taylor County and Priscilla Browning was from Lithia, Hillsborough County, not far from Plant City. Mr. Bailey worked in a country store and later owned and operated his own general store. Mrs. Bailey was trained as a teacher and for a while ran a shop where local women could make their own clothing.

The family moved to Plant City in 1923; Mrs. Bailey and the young David had become ill because of the malaria epidemic. Mr. Bailey opened and operated a dry goods store, Bailey's Cash Store, but had to close when the Great Depression set in. Mrs. Bailey went back to teaching, and the young D.E. and his brother, Alda Merrill, attended the Strawberry Schools or regular schools following their mother's teaching positions.

D.E. attended the 1914 Plant City High School, excelling in Latin, English and history, and graduated in 1934. Opting for a smaller school than the University of Florida, D.E. worked on local farms and in a department store for a year before entering Florida Southern College in Lakeland, Florida. He worked in the college maintenance department and waited tables to pay for school and received his teaching certificate in 1937.

After teaching in fifth and sixth grades in a small school near Tampa, D.E. received a teaching position at Plant City High School and taught English, history and speech. He also sponsored the school newspaper and directed the Drama Club. During this time, D.E. became popular and respected by the school administrators, faculty and students. He also met Eloise DuBois, who he knew from high school and who was now teaching in a nearby school. They were married in August 1940.

In March 1941 D.E. Bailey was the first married man from Plant City to be drafted into the U.S Army. His brother, Alda, withdrew from college to join him, and both served in the U.S. Army. D.E. served in the South Pacific (New Guinea, the Dutch East Indies and the Philippines) and returned home in 1945. His son, David Merrill Bailey, was fourteen months old before D.E. first saw him.

D.E. returned to Plant City High School in 1945 and resumed teaching English, history, journalism and speech. He was appointed principal at Knights Elementary School, just north of Plant City, then Stonewall Jackson Elementary School, and from 1957 until he retired in 1977 he was principal at William Jennings Bryan Elementary School in Plant City. He also took the opportunity to return to school himself, receiving his master's degree in elementary and secondary school administration, with minors in history and other social studies disciplines.

David E. Bailey Jr., shown here in 1946 after returning from military service in the United States Army during World War II, taught English, speech, journalism and social studies at Plant City High School.

# The Heritage Award: Two Profiles

Active in the community, education and civic affairs, D.E. also taught a Bible class at the First Baptist Church of Plant City for forty-eight years. He belonged to the Plant City Lions Club and later the Kiwanis Club, was the chairman of the board of the Hillsborough Education Association and was active in the Hillsborough Council of Elementary School Principals. He also served on the executive board of the Florida Department of Elementary Schools, on the Florida Education Council, on the State Mission Board of the Florida Baptist Convention and on the Florida Baptist Historical Society.

D.E. wrote a brief history of Plant City, which was published in a special edition of the *Plant City Courier*. He later teamed with Quintilla Geer Bruton, who was married to Judge James Bruton and who was active in the Plant City Woman's Club and was instrumental in establishing the public library in Plant City. The two of them wrote *Plant City: Its Origin and History* in 1977, and published an updated edition of the book in 1984 in conjunction with the celebration of the city's centennial anniversary in 1985.

D.E. Bailey is a charter board member of the East Hillsborough Historical Society and a member of the Tampa Bay Historical Society and the Florida Historical Society. He also serves on the Advisory Council of Plant City Photo Archives. He has received the Outstanding Citizen of the Year award from the city's civic clubs and has been awarded Florida Southern College's alumni award for Distinguished Service to Humanity. The Plant City Photo Archives presented D.E. Bailey the Heritage Award in 2004 for his outstanding contribution to the preservation of the history and heritage of the greater Plant City community.

## *James L. "Jim" Redman*

James L. Redman was a Plant City native born in January 1932. His father, James W. Redman, was in the farm supply business and managed the local Kilgore Seed Company. Jim attended local schools and graduated from Plant City High School in 1949. While there he developed a respect for and friendship with one of his teachers, D.E. Bailey, who said that Jim Redman was the most outstanding student-athlete that he had ever taught. Redman was co-captain of the football team and played on the basketball and baseball teams.

Jim Redman was not a man to waste time and after graduation he immediately set off for the University of Florida, where he worked to pay his way through his four-year program, graduating in 1953 with a business degree and a minor in accounting. Commissioned as an officer in the United

David E. Bailey Jr. and his wife, Eloise DuBois Bailey, both educators, were married in August 1940. They had two children—a son, David, and a daughter, Randi Sue.

# The Heritage Award: Two Profiles

James L. Redman and Ruby Jean Barker were friends from youth. They were married in 1957 and have three children, Susan, Pam and Jeanne, all of Plant City, Florida.

# *Remembering* **Plant City**

Among other achievements for the remarkable James L. Redman, who was an outstanding scholastic athlete and scholar, is the award as the Most Valuable Member of the House of Representatives in 1975. He was also called the "conscience of the House." He represented Plant City and the sixty-second district from 1966 to 1978.

States Air Force, Jim Redman served in the United States and in England, then returned to enroll in the University of Florida Law School.

Jim Redman and Ruby Jean Barker had known each other since they were young, and were friends through school. Her parents ran a dry goods store, Barkers' Department Store, near the center of town. In 1953, Ruby Jean was crowned queen of the Strawberry Festival. She studied teaching at Florida State University, and she and Jim were married in 1957, while Jim was still in his final year of law school.

# The Heritage Award: Two Profiles

Before the ink was dry on his diploma, Jim Redman hurried back to Plant City to his first job as an attorney with the law firm of Woody Liles and Bob Edwards. He was active in civic affairs, was a member of the Plant City Lions Club and worked with the First Baptist Church.

Service to the community had always been important to Jim Redman and in 1965 he ran successfully for the Florida House of Representatives and served twelve outstanding years in Tallahassee. He would not tolerate unethical behavior by public servants and ran committees that investigated charges against the state treasurer, state education commissioner and the lieutenant governor. He was called "the conscience of the House," was named majority leader in 1974 and in 1975 the *St. Petersburg Times* named him the Most Valuable Member of the House of Representatives.

When a number of Hillsborough County Commissioners were indicted, the governor appointed Jim Redman an interim county commissioner, and he served with distinction. Jan Platt, who served on the County Commission with Redman, said he set the standard for integrity in government.

He returned to work with the law firm of Trinkle, Redman, et al., and worked as regular a schedule as possible. He always wore a coat and tie, and chided those attorneys who did not. In his years Jim Redman never took an alcoholic drink or smoked a cigarette. He was a deacon and a regular Sunday school teacher at First Baptist Church. In 1974 Jim and Ruby Jean's family were named the Family of the Year in Plant City. In 1976 Redman was named the Outstanding Citizen of the Year. A section of State Road 39 was renamed the James L. Redman Parkway; the Hillsborough County Commission awarded him the Ellsworth Simmons Good Government Award in 1999; and in 1980 Plant City proclaimed May 14 as Jim Redman Day.

In 1978 Redman was diagnosed with multiple myeloma, a rare blood cancer, and was given six months to live. He sought another opinion, sought out the best medical practitioners, received the best treatment that he could find and moved on. When hearing of another cancer patient, Jim Redman would often visit or call to cheer him up and wish him well. James L. Redman passed away in May 2006. He and Ruby Jean had become very active in the American Cancer Society, where she served on the board of directors, and they regularly formed a team for the Walk For Life Relay. In 2006 they presided over the opening of the James and Ruby Jean Redman Emergency Room wing of the South Florida Baptist Hospital, where he had served on the board for many years.

Jim Redman had served as director and past president of many organizations, including the Florida Strawberry Festival, South Florida

Baptist Hospital and its Foundation and the Plant City Growers Association. He had served as an associate judge for six years, as an officer for the Florida Baptist State Convention, was a longtime member of the Greater Plant City Chamber of Commerce and served on the Advisory Council of the Plant City Photo Archives. He was awarded the Heritage Award for his efforts in the preservation of the community's history and heritage.

# Moving Experiences
## The Relocation of Three Plant City Homes

### The Alsobrook House

In 1907 J.W. Alsobrook, a young medical doctor, purchased from Peter Thomas a vacant lot on North Evers Street in Plant City. The lot was just north of the Primitive Baptist Church, and across the street from the lot where the 1914 Plant City High School would later be constructed. The oversized lot soon became the site for the large and stately home Dr. Alsobrook built for his bride, Margaret Kilpatrick Alsobrook. There they raised their only child, Elizabeth.

Dr. Alsobrook died in 1945, and Margaret followed in 1955, leaving the home to their daughter, Elizabeth. W. Victor Smith and his wife Robbie purchased the home from Elizabeth at that time. Included in the sale of the home were some of Margaret's personal items: some books from her school years, some of Dr. Alsobrook's guns and several pieces of fine furnishings and heirlooms.

Mary Jane (Jackson) Parolini, a former strawberry queen, grew up in that house. Mary Jane's mother was a sister to Robbie Smith, and when Mary Jane's parents divorced, Mary Jane, her two sisters and her mother were invited to live with the Smiths and their five children. Mary Jane speaks through a light, breathless voice, seeming almost spellbound, when she conveys the happy and loving environment that flourished within the walls of the spacious home throughout her growing years there. She recalls

In 1907 Dr. J.W. Alsobrook bought this lot and constructed this lovely home. The 1914 Plant City High School was later built across the street from it. In the late 1960s the land was sold and the house was moved several miles west and relocated on Whitehall Street.

with endearment that the wedding reception given for her marriage to Bill Parolini took place in the Alsobrook/Smith home.

In the late 1960s, Robbie Smith passed away; W. Victor Smith then had the house moved from its Evers Street location about a mile west to 508 Whitehall Street, where it continued to stand. Victor Smith remarried and lived there with his wife Edith from 1975 to 1983. Edith Smith loved the old house and spoke of its innate happiness; after the children had all grown and moved out, however, it proved to be too large. They sold the house, bought a smaller house in the historic district and had it moved to a new location.

# Moving Experiences:
## The Relocation of Three Plant City Homes

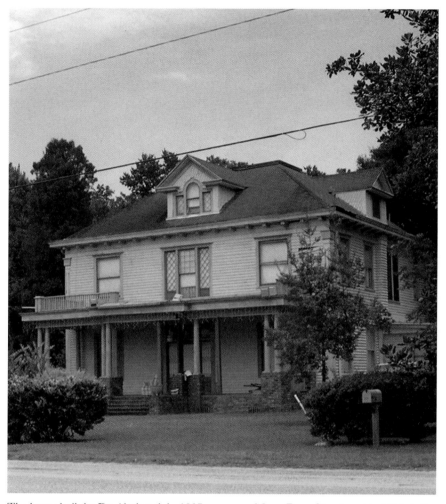

The house built by Dr. Alsobrook in 1907 was moved from Evers Street west to Whitehall Street in the 1960s. This is the house in 2003.

The Goldbergs bought the house in 1983, and then Mrs. Joyce Bittman bought it in 1988 and she and her family have lived there since. She, too, spoke of the character of the house and the love that it seems to exude.

## The Austin House

Dr. Edgar Austin from Golconda, Illinois, moved to Plant City with his wife and two daughters in 1926. He and his family settled into a two-story residence located between Pennsylvania Avenue and Knight Street, on the east side of town. When he died his daughter, Eloise Austin Cameron, inherited the house.

# *Remembering* **Plant City**

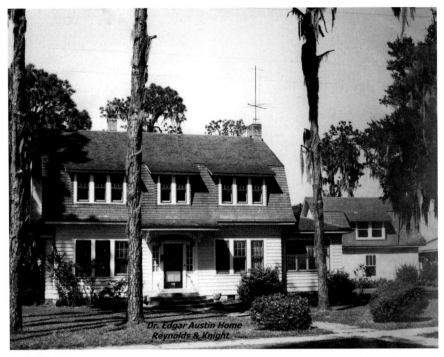

Dr. Edgar Austin Home
Reynolds & Knight

Dr. Edgar Austin bought this residence some time after 1926. After Dr. Austin died, his daughter sold the property to James T. Pollock as part of the plot for Mr. Pollock's PaceMaster Corporation. Pollock then sold the house to James and Ola Jean Hardee, who arranged to have it moved all in one piece to its new location on North Knight Street in 1972.

About 1970 James T. Pollock, founder of PaceMaster Oil Corporation, bought the property from Eloise Cameron with the agreement that within a year she would either sell the house or have it razed. Neither of these two actions had taken place within the time frame and, in late 1971, Pollock sold the house to James and Ola Jean Hardee.

In early 1972, the Hardees had the Austin home moved from the Reynolds Street location to a quiet residential spot at 1112 North Knight Street. They and their two children moved into their new home in September of 1972. The Austin/Hardee home still sits on that lot in its historic elegance, and except for maintenance and repair, restoration and some modifications and additions, the house is 90 percent original. Ola Jean Hardee exclaims that she has a passion for old houses and only regrets not relocating the old garage/carriage house at the same time. It was later torn down.

# Moving Experiences:
## The Relocation of Three Plant City Homes

This is the former Dr. Austin residence, now owned by James and Ola Jean Hardee, who had it moved about a half-mile to its lovely new setting in 1972.

## The Young House

Colonel James Laurens Young, of Scottish ancestry, was an attorney who came to Plant City in 1886, where he and his wife, Jennie, raised their two sons, Roger L. and Calvin T. Young. At some point after their arrival in Plant City they had a large, elegant home built on the southwest corner of Reynolds Street and Evers Street, in the downtown district.

In addition to his law practice, Colonel Young was elected to the Florida House of Representatives in 1899 and again in 1901. After retiring from his law practice, Colonel Young helped organize the Hillsboro State Bank in 1902, and served as president until his death in 1928. After Jennie Young died in 1933, Dr. Calvin T. Young and his wife moved into the big house. In addition to his medical practice, Dr. Young was an officer of the State Board of Health and served as president of the State Board for four years. He served as president of Hillsboro State Bank from 1948 until his death in 1955. Dr. Young's wife had died in 1938; they had no children.

# *Remembering* **Plant City**

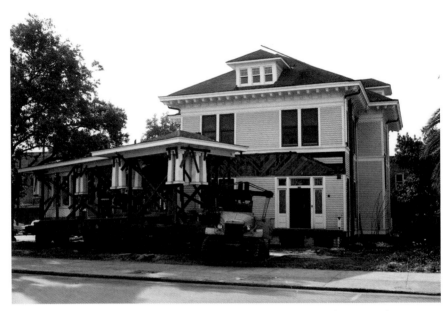

Colonel James Laurens Young had this house built near the center of town on the southwest corner of Evers and Reynolds Streets about the turn of the century. Following his death in 1928, his son, Dr. Calvin T. Young, and his wife lived in the house. After their passing, the Hillsboro State Bank bought the property and sold the house to Dr. Ben and Mrs. Marion Gatliff who, in 1956, had it moved to West Baker Street. They resided there with their children until 1971.

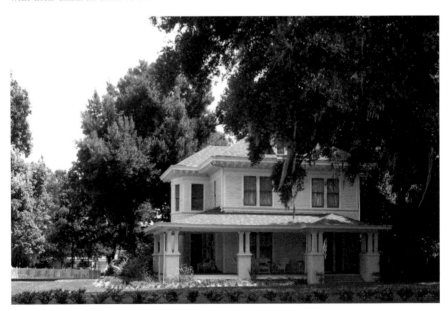

This is the relocated Colonel Young/Dr. Young/Dr. Gatliff home on West Baker Street as it looked in 2005.

# Moving Experiences:
## The Relocation of Three Plant City Homes

Following the death of Dr. Young, Hillsboro State Bank purchased the property for the construction of a drive-through banking facility, and the house was to be torn down. Dr. Ben Gatliff was told of this by the new bank president, Arthur Boring, and promptly changed his plans. Dr. Gatliff and his wife had purchased two lots and had plans drawn up to construct a new residence. The Gatliffs bought the old house, had it cut in half and moved it a mile west to a large lot on West Baker Street, near the then outskirts of town. There they settled in and raised their three children.

Dr. and Mrs. Gatliff lived in the old Young house from 1956 to 1971. There they had filled in an old pond on the property and surrounded the house with plants; when they moved to a smaller house in the Pinedale subdivision, Mrs. Gatliff transplanted her beloved azaleas to the new garden.

The old Colonel Young house is still at the West Baker Street location. It continues to be maintained well and repainted frequently, and remains an elegant historic structure.

# Plant City Union Station
*"The Depot"*

On the heels of the American Civil War came a massive growth in the settlement of virgin lands made possible by the invention of the steam locomotive. Homesteaders claimed 80 million acres of newly opened lands, while the railroads were given 180 million acres in land grants to encourage development. Homesteaders in Plant City area were involved in raising cattle, growing citrus and cotton, logging and phosphate mining.

In early 1883, Henry Bradley Plant, through the Plant Investment Company, purchased the charter of another railroad that had the authority to build a railroad between Tampa and Kissimmee. On December 10, 1883, the first South Florida Railroad train arrived in Plant City from Tampa. One month later, these tracks joined tracks to Sanford, where connection was made with steamboats on the St. Johns River.

In the path of this progress, the new town of Plant City, named in honor of Henry B. Plant, was chartered on January 10, 1885. The town soon had an organized government, business establishments, churches, a post office and a school. Plant City was described in the state's oldest weekly newspaper, the *Florida Gazetteer*, as a "prosperous place." The *South Florida Courier*, later known as the *Courier*, was first published the same year: 1885.

In 1889, the Florida Central and Peninsular Railroad extended its tracks from Waldo to Tampa, crossing the South Florida Railroad tracks adjacent to downtown Plant City. In 1902, the Florida Central and Peninsular

## Plant City Union Station: "The Depot"

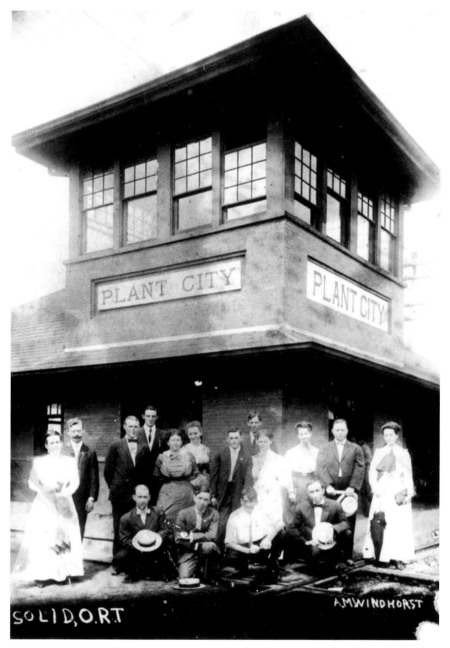

The Plant City Union Station was immediately a hit with the local citizenry and became a hub of activity. The station was completed in 1909 and became one of the busiest railroad stations and shipping platforms in all of Florida.

# *Remembering* **Plant City**

The new Plant City Union Station was a modern facility in 1910, as is seen in this photograph of the office.

Railroad merged into the Seaboard Air Line Railroad, while Mr. Plant's South Florida Railroad merged into the Atlantic Coast Line Railroad. These mergers extended the tracks of both railroads from west central Florida to Richmond, Virginia.

Union Passenger Station was completed in 1909 and sat in the downtown area along Palmer Street, one block south of Reynolds Street (U.S. 92) and one block east of Collins Street (State Road 39), where several tracks crossed. It was used by both railroads for their passenger service and for mail, as well as for Western Union telegraph service. Between 1909 and 1960, this station was one of the town's focal points. From this platform soldiers went off to war to tears and returned from service to cheers. People came to the station to receive news and to bid farewell to or greet passengers. People stopped in to socialize or just to watch trains arrive and depart, all activities of a bygone era.

By 1920, many railroad carloads of farm produce (1,200 carloads in 1920) were being shipped in wooden crates. Strawberries were first shipped in 1892, and by 1902, so many were being shipped that Plant City claimed the title of the "Winter Strawberry Capital of the World."

With the coming of the jet airliner in the late 1950s and the interstate highway system in the 1960s, the once busy station was bypassed and soon became a relic. In 1974, the railroad deeded the building to the city and,

# Plant City Union Station: "The Depot"

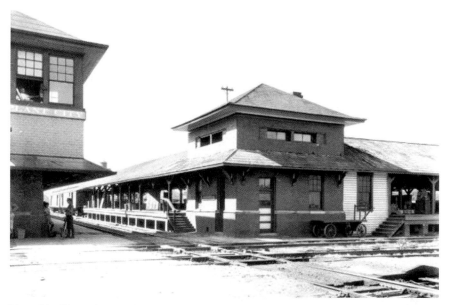

Plant City Union Station passenger platform (to the left) and shipping platform (on the right) as they looked in 1924. This juncture of north-south, east-west traffic saw sixty to one hundred trains pass through Plant City on a daily basis.

in 1977, Union Station was listed on the National Register of Historic Places. The freight and shipping platforms have since been torn down, and the tower building was moved from the east side of the tracks to the west side, adjacent to the passenger station, whose platform was also moved well away from the busy tracks. Since December 11, 1997, it has served as a Visitors' Center, which includes a railroad museum and mini-theatre in the old baggage room for visitor orientation. The old Union Station continues to serve the community as the hub for most downtown activities, car shows, bike shows, antique sales, art shows and the like.

Please visit us at
www.historypress.net